The Art Kettle

The Art Kettle

Sinéad Murphy

Winchester, UK
Washington, USA

First published by Zero Books, 2012
Zero Books is an imprint of John Hunt Publishing Ltd., Laurel House, Station Approach,
Alresford, Hants, SO24 9JH, UK
office1@o-books.net
www.o-books.com

For distributor details and how to order please visit the 'Ordering' section on our website.

Text copyright: Sinéad Murphy 2010

ISBN: 978 1 84694 984 5

A CIP catalogue record for this book is available from the British Library.

Design: Stuart Davies

Printed in the UK by CPI Antony Rowe
Printed in the USA by Offset Paperback Mfrs, Inc

We operate a distinctive and ethical publishing philosophy in all
areas of our business, from our global network of authors to
production and worldwide distribution.

CONTENTS

"I fear you are a heretic about art generally. How is that? I should have expected you to be very sensitive to the beautiful everywhere."

"I suppose I am dull about many things," said Dorothea, simply. "I should like to make life beautiful—I mean everybody's life. And then all this immense expense of art, that seems somehow to lie outside life and make it no better for the world, pains one."

George Eliot, *Middlemarch*

Parliament Square

It would be nice to suppose that we could begin here with: "We're all aware of the occasion, on 9 December 2010, when police in London adopted the paramilitary tactic called 'kettling' and restricted the movement of a crowd of lawful protestors, blocking entrance to and exit from Parliament Square for a period of around eight hours." But we cannot begin thus, for the sad truth is that awareness of this occasion, never very strong, is now waned almost completely. This is a *sad* truth because, on the 9 December 2010, the British government used the London Metropolitan Police effectively to manipulate public perception of protests at student cuts, making it far more likely that the protestors, and, by implication, their objections to government cuts to spending on higher education in the Arts, Humanities, and Social Sciences, would be judged irrational, trouble-seeking and deserving of our censure. The use of the police to push through government decisions, in the face of fully lawful resistance to those decisions, is not something to which any government pretending to democracy ought to resort, nor any population committed to basic democratic freedoms ought to submit.

But this "kettling" technique, now fast becoming an almost procedural feature of British government, is nothing new, not even to Parliament Square, London. In June 2001, a man called Brian Haw began his own protest against another British government decision, the one to invade Iraq. Haw produced and collected placards and other objects, expressive of his and others' opposition to the invasion, displaying them neatly along one side of Parliament Square. The protest was well conceived:

obtrusive but not offensively so, sustained (Haw lived with it for twenty-four hours a day), and of course right on the pulse of political events and visible to thousands of Britons every day and to their Prime Minister Blair on many days. However, in April 2005 a new Serious Organized Crime and Police Act was passed which had the effect of outlawing unauthorized protests within one kilometre of Parliament Square; in May 2006, five years and forty metres of Parliament Square after its beginning, Haw's protest was almost entirely dismantled. But—and this is the really interesting bit—before it was dismantled it was carefully photographed by the British artist, Mark Wallinger, who then faithfully reconstructed it as a work of art; its title was *State Britain* and it was on exhibition in Tate Britain from January to August 2007. Why this is interesting is that Tate Britain is partly situated within one kilometre of Parliament Square; Wallinger used an arc of black tape to mark the intersection of *State Britain* with the newly-designated exclusion zone. But Wallinger's art work, though indiscernible from Haw's protest, was not dismantled by the police. Haw's protest, become art, had ceased to make itself heard.

What exactly happened here? And what does it suggest about the relation between protest and art, or, to put it more specifically, between our liberal democratic government's mode of managing popular resistance to its decisions, and the social and political effects of that which we call "art"? In one sense, we can reply by saying that nothing much at all happened that was not already commonplace, although somewhat less explicit. On 16 January 2007, *The Guardian* quoted Tony Blair as saying: "When I pass protestors every day at Downing Street, and believe me, you name it, they protest against it, I may not like what they call me, but I thank God they can. That's called freedom." What is significant about this comment is the manner in which it defuses the *content* of particular protests by highlighting merely their *form* as protest ("you name it, they protest against it"), and then actually

moves to call upon all protests, by virtue of their very prolifer-
ation, as supports for the liberal democracy against at least
aspects of which they would, if they could!, protest ("I may not
like what they call me, but I thank God they can. That's called
freedom.").

In this short reaction to Haw's protest, Blair, very astutely,
availed himself of the fact that liberal democracy is further
justified and strengthened in direct proportion to the extent of
the presence it allows to criticism of itself; the louder the protest
can be heard, the more tolerant and therefore "liberal" the
regime that gives it its airtime. Which means, of course, that
protest against liberal democratic governments is not, at least not
straightforwardly, possible, given that any protest, whatever its
content, unwittingly lends support to the apparent liberality of
the polity that not only permits it to happen but "thanks God"
that it can. We might, therefore, begin to think that the disman-
tling of Haw's protest under the Serious Organized Crime and
Police Act merely makes explicit the subtle dismantling of possi-
bilities for protest achieved by a government bent on protecting
the "freedom" of its citizens, and that its transportation from the
political realm to the art museum merely enacts the extent to
which the political commitment to "freedom" as a regulative
ideal tends, once it begins to operate at the level of form rather
than content, to reduce political action to a mere performance of
action, to remake it as an "installation" with merely aesthetic
import, and thereby to manage very well its scope and its effects.

Let us, for a final episode in this opening sad tale, stay in Tate
Britain, which is now partly situated within Parliament Square,
understood as that sacrosanct territory in which protest must be
authorized. It is the evening of 7 December 2010. Outside in the
entrance hall, invisible but audible, is the remains of a protest
(illegal if the entrance hall falls within the zone of exclusion) by
students from London art colleges, at the recent announcement
of government cuts to funding for higher education in the Arts,

Humanities and Social Sciences. Inside, also invisible but audible, Susan Phillipsz's *Lowlands Away* wins the year's Turner Prize for being the "outstanding" work of a British artist under the age of 50. Nicolas Serota, director of the Tate, speaks for both outside and in, when, in compliment to Philipsz and with an ironic nod in the direction of the chants of the protestors, he observes that "now seems to be all about sound."

Philipsz, the morning after the event, recalled the presence of the protestors as "a surreal experience. The particular acoustics in the gallery," she said, "made it seem like it was a dream—the way the cheering and the chanting carried." So here, on 7 December 2010, we have the couldn't-have-written-it-better juxtaposition of an award-winning artwork of sound and the sound of a protest destined to fall on deaf ears; here we have a call for popular resistance conflated with a study of the sculptural qualities of the musical voice (this is how Philipsz describes her work); here we have a case of real political dissatisfaction made to sound like a dream to those gathered in honour of a prize whose function, since its inception, appears to be the determination of surprisingly "real" objects and events—the switching on and off of a light, an unmade bed, the sounds of an untrained voice singing a folk song—as, in fact, great pieces of art.

The argument of this book is that this event, on 7 December 2010, carries a great deal more of significance than its merely coincidental appearance might seem to suggest. For the claim here is that the manner in which art is constituted in our society—that is, what we understand art to be and to do, and the value we attribute to what art is and does—operates primarily as a mode of control. We are taught to shy away from the question "What is art for?": part of the way in which art is constituted means that art is understood as, almost by definition, for nothing; art is disinterested, without use or purpose, and this is regarded, not as a vice, but as a virtue, of art. But we ought not to shy away from the question, for the answer to "What is art for?" is: "To

keep us all in good order." Hence the title of this book—*The Art Kettle*—for its thesis is that, just as the "kettling" techniques increasingly being employed by the British government as a way to both physically corral crowds of dissenters and, much more sinister, psychologically herd the population at large through the construction and distribution of the figure of the student-protestor-as-threatening-vandal, so what we call "art" operates to physically and psychologically contain a growing population of allegedly "free" thinkers, speakers, movers and livers. It does this by regulating the manner in which our capacities for creativity, for inventiveness, for imagination, our capacities to interpret, to judge, to experience, seek and find what is perceived to be their most fitting expression, leaving the rest of social, cultural and political life free of such unpredictable, such poten-tially revolutionary, capacities, all the better for our uninter-rupted control by the almost-global forces of mass uniformity and constant, small-scale, change that suit so well the interests of capital to which liberal democracy seems now inextricably tied.

When Susan Philipsz confessed to having experienced the sound of chants of protest at government cuts as if they were in a dream, she could not have summarized more accurately the extent to which, in its simultaneous monopolizing of the creative impulse and designation of that impulse as necessarily extricated from any purpose, as *for* nothing, what we call "art" has rendered un-real the possibilities for "free thinking" and for resistance that are supposed to lie at the heart of our political system. When Brian Haw's protest against the invasion of Iraq was dismantled into an artwork, this kettle-effect of art was made just a little less subtle. That our government now begins to "kettle" more blatantly, shortcutting the route through art altogether by simply sending the police out onto the streets, and that this development coincides so closely with government cuts to funding for art, may be the effect of an art kettle that has worked so well it is no longer required: when a population has

ceased to judge for itself, what need any more for a convoluted regulation of its judgement? Either that, or liberal democracy is growing careless, too careless to present its excessive need for control as anything other than what it is.

2

Stuck! Stuck! Stuck!

But what is this thing called "art," of the mode of constitution of which we are making so much? Or, to put it in the terms being used here: in what manner has "art" been constituted so as to produce the kettling effect to which we should object and offer resistance? Simply stated: "art" is that which is constituted around the simultaneous irrelevance of the question "What is art for?" and relevance of the question "What is art?" In other words, art has come to be defined as that sphere of practice, that set of objects, that institution, for which questions about the nature of itself are central, and use or purpose are set at nought.

Take *Lowlands Away*, Philipsz's prize-winning work. The piece consists of a recording of Philipsz's untrained voice, singing an old Scottish lament called "Lowlands Away", "mounted" (that is still the technical term) under three bridges that cross Glasgow's River Clyde so that it can be heard by unwitting passers-by. At least that *was* what the work consisted of; the prize-winning work was actually "mounted" in an empty room in Tate Britain and heard by very witting visitors to a museum of art. And the questions that have dominated public and professional debate over the work, and its meriting (or otherwise) of a first in the competition for the Turner Prize, have been about whether or not the work is really a work of art that qualifies for Turner attention (it is, after all, a piece of music and the Turner is intended as a prize for the visual arts), or about whether or not the sound of an untrained voice, which often loses pitch and sometimes control, is appropriate for consideration as an artwork, or about whether a work that was created for a particular environment can, with any degree of integrity, be transported to and appreciated in the

interior of an art museum. In short, the attraction of Philipsz's work appears to inhere, for the most part, in the challenge it poses to a certain conception of visual art, of public art, of good art, or just of art. And, in this, though Philipsz is the first sound artist to win the Turner Prize, and only the fourth female artist to do so, she is no different from so many of her predecessors to the honour. For the question "But is it art?" is the one most commonly associated with the Turner Prize, as, in its honouring works from a cow preserved in formaldehyde to a light going on and off in one of its exhibition rooms, it appears to define itself by the defiant statement of "It *is* art!" rather than by anything to do with the quality or otherwise of works about which the question "Is it art?" would not arise.

Of course, the Turner Prize is no ground-breaking enterprise in this, respect; the question "Is it art?" has been available as a defining feature of artworks, at least since Marcel Duchamp exhibited his *Fountain* in 1917 and perhaps as far back as the exhibition of Manet's paintings in the *Salon des Refusés*, during the 1860s, in which works prostitutes stare straight out at the viewer, or most of the space is covered in men dressed head-to-toe in black, or the oils were applied so thinly as to allow parts of the bare canvas to show through. "It's not art!" the juries of the official *Salon* declared at the time; "It *is* art!" the "*refusés*" replied in their turn. And "It's not art"/"It *is* art" seems to have dominated the field ever since. We might say, then, that art is *stuck*, in a loop of staking a claim to itself and then having that claim contested, in an intensity of navel gazing that prevents it from seeing anything but itself.

Which is precisely the objection, ironically, of the "Stuckists," a group of skeptics of the Turner Prize and "Brit Art" generally, established in 1999 as an outlet for a total derision of the thing that is nowadays called "art," and deriving its name from a statement by the Brit Artist, Tracey Emin, to her then boyfriend, Billy Childish, in which she described him and his paintings as

"Stuck! Stuck! Stuck!," presumably in the tradition from which Emin's work had so controversially appeared to move on. Members of this group were, as it happens, also among the protestors in the entrance lobby of Tate Britain on the night Susan Philipsz was awarded her prize; their cries of "The Turner Prize is Crap!" were muffled on the night by the chants of those protesting against government cuts, and have certainly been forgotten since in the little mêlée of artist, journalist, and public support for the students' grievances. But what goes unnoticed by all, including the Stuckists, is the close connection between the mode of existence of art against which the Stuckists were protesting and the cuts to funding for the arts against which the students were protesting. For, an art whose parameters are the loop of "It's not art"/"It *is* art" functions precisely as that kind of safety valve for a potentially dangerous creative energy, which a government employs to great effect that is generally concerned to limit its citizens' education in those disciplines (the Arts, Humanities and Social Sciences) in which they might be taught to understand and to question ideas. (And this is not a new concern of a new government; under "New" Labour, science subjects were hugely disproportionately funded by government, despite the fact that demand to study them was relatively low and they are statistically less likely to lead to employment.) Although nobody thought so on the night, cries of "The Turner Prize is Crap!" and "Stop Government Cuts!" had the same end in sight.

One of the Stuckists' manifestos takes the form of a letter, written to the director of the then Tate (soon to be Tate Britain), Nicholas Serota, in February 2000, in which, among many other things, they accuse his institution of sponsoring the disappearance of art into life. Referring in this instance to Serota's purchase, on behalf of the Tate, of Joseph Beuys' basalt blocks (for the sum of £700k), the Stuckists accuse Serota of making redundant the specialness of art by giving institutional backing

to objects, like bricks, which are not, unless you make an imaginative leap that you could make with anything at all if you had a mind to do so, "about" anything. Such objects are *for* something, the Stuckists concede, but they are not *about* anything. By sponsoring such objects as art, the Stuckists' claim is that Serota is sponsoring the "logical progression of art into life" and therefore the extinction of art. "Well done!" they add, and presumably with a degree of irony to be implied. But the Stuckists, after all, have missed a very important trick, and one that becomes rather sinisterly clear upon consideration of another artwork that looks just like an object in its environment and that actually won the Turner Prize in 2007: Mark Wallinger's *State Britain*.

The official Turner Prize pages on Tate Britain's website report that the jury recommended Wallinger's work for its "immediacy, visceral intensity and historic importance" and for its being a "bold political statement." Given, however, that, by comparison with the protest of which Wallinger's work is described as a "direct representation" (from which, in fact, it is "indiscernible"), *State Britain* is characterized precisely by its *lack* of immediacy (it is no longer in view of any but a very controlled number of the public) and its *lack* of intensity (Wallinger did not live with his work for 24 hours a day, traffic was not rushing by, the Prime Minister was unlikely to see it...need we go on?), we can only presume that its "historic importance," if indeed it has or will have any, lies not in its immediacy and intensity *per se* but rather in the immediacy and intensity with which it confronts us with the fact of its being considered as art, and as award-winning art. Nobody with any mindfulness of Haw could describe Wallinger's work as a "bold political statement"; the irony of the claim is almost too painful to bear. It is, rather, an artwork made of a bold political statement, or a bold political statement made into art (and therefore no longer bold), so that the Stuckists' fear that the rage for indiscernibles represents *a progression of art into life* gets

it the wrong way around: art that is concerned only about the loop "It's not art"/"It *is* art" (the "indiscernible" is a most fitting site for this loop) functions much more consistently to *remove art*—and the imaginative, intense, bold, and immediate resistances of which the creative, the "artistic," spirit is capable—*from life*. Parliament Square is clear again; free thinking, resistance, protest, is hidden away in the art museum: and life goes on as before. A disappearance of life into art, if you like; but certainly not a disappearance of art into life.

But is not all of this rather by-the-way, an over-intellectualized and very marginal response to artworks that are, by most, encountered on utterly different terms? Is art really constituted in the manner we have just described? After all, one likely response to our account here of the nature and implications of Philipsz's work would be: "Whether or not 'Lowlands Away' is art is a question in which I am not interested. I just think it's beautiful, and that's enough for me." Indeed this is a version of the response of Chris Bohn, the editor of *Wire* magazine's "Rewind" edition of December 2010; he scoffs at the controversy over whether or not the winner of the year's Turner Prize is or is not art as tweedy nonsense, saying "Pardon me for stating the obvious, but 'Is it art?' is the wrong question. Let's try again," he continues, "with 'Does it move me?'" and he goes on to describe what he calls the "rare moment of true feeling" that Philipsz's work occasions, a feeling, he says, that "cannot be faked." "Was it good for you too?" he ends, rather naughtily, by asking. Bohn is contemptuous of the over-involved media debates of "It's not art"/"It *is* art" and encourages us "instead" to appreciate the way the work makes us *feel*. But "instead" is put here between scare codes, because this focus on the way that a work of art makes us feel, and, in particular, the tendency—deeply rooted in our tradition—to attribute to such feeling a kind of *truth* not available anywhere else, is one that, in its historical emergence as opposed to considerations of use and purpose, removes art and

our conception of creativity more generally from possibilities for everyday living. The emphasis on feeling, then, is as much a mechanism of the art kettle as is the "It's not art"/"It *is* art" loop, which loop is, in fact, the contemporary inheritor of the tradition that defined art as the occasion for "true feeling." It will require a short account of that tradition to convince you that this is the case, that the occasions for feeling provided by art may also function as occasions for control, but this will bring us very neatly to that other element of the constitution of art named at the outset of this chapter: its obviation of the question "What's art for?"; its elimination, in short, of utility.

3

Disinterested Parties

In 1878, art went on trial at London's Old Bailey: British painter James Abbott McNeill Whistler sued the art critic, John Ruskin, for publishing a review of Whistler's *Nocturne in Black and Gold* which summarily dismissed the painting with the observation that, though he, Ruskin, had seen and heard much of Cockney impudence before then, he had "never expected to hear of a coxcomb ask two hundred guineas for flinging a pot of paint in the public's face." Whistler testified at the trial, often entertaining those gathered with witty replies to the Attorney General's sometimes naive interrogation: "Do you not think that anybody looking at that picture might fairly come to the conclusion that it had no peculiar beauty?" the attorney, Sir John Holker, asked Whistler. "I have strong evidence that Mr. Ruskin did come to that conclusion," Whistler replied. "Do you think it fair that Mr. Ruskin should come to that conclusion?" Holker pressed. "What might be fair to Mr. Ruskin I can't answer," Whistler responded. "No artist of culture would come to that conclusion." "You offer that picture to the public as one of particular beauty as a work of art, and which is fairly worth two hundred guineas?" Holker then asked. "I offer it as a work which I have conscientiously executed, and which I think worth the money," was Whistler's somewhat ambiguous reply.

This is a deceptively rich exchange, in part because of what might appear to us now as the Attorney General's innocent assurance that art must be, straightforwardly, *beautiful*. Whistler's painting, it seems to him, is not beautiful, and so does not qualify as art. But, in this, Ruskin's attorney is only apparently a naif, for he is, in fact, a contemporary version of *Wire's*

editor, whose review of Philipsz's *Lowlands Away* describes the manner in which her wavering voice "competes for *your* attention" with the noise of a public place, with "whatever happens to be on *your* mind as *you* come within range of it," and "plants an earworm that carries on wriggling long after *you* have moved on." The fact that all these *you*s are sandwiched between Bohn's claim that the crucial question when it comes to art is "Does it move *me*?" and his observation that "Of course art is personal and it never works the same way for everyone," merely serves to illuminate the fact that what he is describing as the effect of Philipsz's work is assumed to be, if personal, then personal to all, that which I *and you* would (or should) experience on encountering it; therein, we can take it, lies the "rarity" and "truth" that Bohn attributes to it. Like the lawyer at the Old Bailey, then, who expects art to be found beautiful by the public, the editor of *Wire* magazine expects art to be found, not beautiful, which is now a troubled word, but "moving" by his readers. And Whistler disagrees, with Ruskin's lawyer and with our editor. For, Whistler is unconcerned by whether or not you and I are moved by his work. Cleverly circumventing the attorney's question about the public, his claim is simply that no "artist of culture" would dispute his *Nocturne*'s beauty; note also his total neglect of the question about whether "anybody" looking at the work would fail to find it beautiful. For Whistler, "anybody" was of little or no interest; only the "cultured" count.

Now, Ruskin the art critic was a more nuanced judge of art than his legal representative at the trial. Already something of a controversial figure for his support of the later works of, yes, Turner, works that Sir John Holker would have seen no beauty in and that the public at that time also struggled to appreciate, Ruskin's dislike of Whistler's work was founded upon two objections, neither of which was simply that Whistler did not make beautiful paintings: first, that Whistler, in producing works of art, sought to address only a chosen few, only artists like himself;

and, second, that, in so doing, Whistler paid no heed to the capacity of artworks to enlighten those who looked at them, by their representation of what was "rare and true" in nature, including in human nature, but rendered low subject matter in a style not calculated to elevate his audience. In short, Ruskin's view was that Whistler's paintings were indulgent experiments in art itself rather than devotional handmaids of right and of good, mere studies in human endeavour rather than humble conduits of an inhuman truth. And Whistler, defiantly, admitted it: "I have meant," he explained at the trial, "rather to indicate an artistic interest alone in the work, divesting the picture of any outside sort of interest which might have been otherwise attached to it." For Ruskin, this amounted to a flinging of art in the public's face, and an elitism anathema to his socialist commitments, just as, for Chris Bohn, the naval-gazing debate of "It's not art"/"It *is* art," spoken in "cut-glass, tweedy vowelled voices bespeaking the best education class privilege can buy," is an effort to corral the possibility of the public being "moved," made by a privileged set that *thinks* too much to *feel* anything at all.

What we have with Whistler versus Ruskin, then, is the dividing up of a territory, the parameters of which continue to delineate the mode of existence of art in our times, sharing out the possibilities for art, between an exercise in the elevation of the masses and an experiment in the artistic interests of the few, between an occasion for true feeling and a site of disputed merit, between nature and culture if you will, or between morality and originality. In 1878, Whistler's was the new and controversial view, and Ruskin's the traditional and accepted one, though often given a thoughtless airing like that by his lawyer at the trial; in 2011, the purely "artistic interest" in art that Whistler fought so hard to defend has become the institutionally accepted one, and it is up to the editors of magazines not overly concerned with institutions but very concerned to upset the established social structures that such institutions buttress, to champion the

view, a version of Ruskin's, that artworks are those rare objects or events that move us because they are true.

Is it not curious, then, that the most recent winner of the Turner prize has been claimed by both of our interested parties, by those who think of the question "Is it art?" as of greatest importance, and by those who think that such a question is irrelevant compared with the question of whether or not the work is moving? Is it not strange that those interested only in questions about the nature of art appear satisfied, or exercised, by Philipsz's work, and that those who look to art for its moral effect appear also to be satisfied, or exercised, by Philipsz's work? Strange indeed, but only if these two, opposite, interests in art are as opposite as they appear to be; not strange at all, if it turns out that they share an awful lot more than they dispute. And they do. For the one thing upon which Ruskin and Whistler did agree is that art is without purpose, that art is not *for* anything, that art is a site of, so the philosophical term goes, "disinterest." Whistler is very explicit about this, defiantly resisting Ruskin's expectation that art serves a moralizing function, by claiming that his works have no "outside interest" attached to them and exhibit only an interest in art itself; his, in short, is an art about art, an art for art. But Ruskin's insistence that art is for the moral does not amount to an insistence that art be attached to an "outside interest" either; indeed, Ruskin followed a well-established tradition for which art is a preparation for moral life precisely insofar as it demands of its audience the kind of remove from purpose, the kind of disinterestedness, that is also required of them as moral agents. For Ruskin, the beauty of art consists precisely in its being the occasion of a feeling that is without the interests that so muddy our everyday lives, a feeling that arises from the sense we get of natural purpose, of a higher power, when we suspend for a moment all of those merely human purposes that cloud our judgment and blind us to our true destiny.

The apparently opposed reactions to *Lowlands Away*, those of

the tweedy thinkers and the trendy movers, are *only apparently opposed*, then, in that they share the presupposition that defines the other aspect of the contemporary constitution of art that we have named here: the presupposition that art—in being either interested only in questions to do with art, or concerned with moving the multitudes to an experience of truth that is "rare" because it comprises only the sense (inevitably rare) of being suspended without purpose—is without use, without aim, without agenda, without determination, without interest. Art, both Ruskin and Whistler, both the "movers" and the "thinkers," agree, is the obviation of the question "What is it *for*?"

In this context, the Stuckists' desire to leave an artworld now bursting at the seams with things that ought only to be *for* something (things like urinals, and Brillo boxes, and basalt blocks, and beds, and light switches), to return to the tradition of painting, when art was, as they say, "about" something, is rather naive. First, because it has been much longer than they think since art was "about" something; before it was about nothing but itself, it was about nothing but the morally elevating effect of occasions that are about nothing. And, second, because the emergence of the *painting*—as opposed to the sculpture, or the fresco, or the poem, or the ballet—as the paradigm of an artwork has everything to do with the abstraction of art from the "aboutness," the purposefulness, of human existence. Malraux explains very well that the painting became definitive of art when the museum became definitive of art—it is much easier to carry about and display a canvas than it is a marble statue or a mosaic, or, for that matter, a lyric poem. And the museum emerged as the home of art when art emerged as the occasion for disinterestedness. When one enters the museum, with its large, silent rooms, and cold floors, and empty spaces, and lack of furnishing, and only art as far as the eye can see, one performs that remove from the exigencies of life that has become definitive of the nature of art. One steps into a realm in which, to properly

engage, one must disengage: and this, whether one has what Whistler called "artistic interest" only, or whether one is looking to be "moved" by a rare moment of truth.

Statement 18 of one of their manifestos claims that the Stuckists oppose the white walls of the museum and demand access to sofas, tables, chairs and cups of tea. But it's too late for this simple bringing home of art, too late to think that all we need to do is get out of Tate Britain, and into our living rooms or under the bridges over the River Clyde. For the museum is famously now without walls, and the values it was built to instil are now so firmly in place that an artwork "mounted" (the language of the museum is as vibrant as its mentality) for the public on its way to work is not more likely to be seen or heard as an intervention of use, of interest, or of purpose, than it would be were it playing in an empty room in Tate Britain. Immediately after the Stuckists claim that artists who don't paint aren't artists, they claim that art that has to be in a gallery isn't art. But they are not only desperately muddled, they are far too behindhand. For, by now, all artists are, effectively, painters, and the world is the gallery in which their art is mounted and experienced without interest, to no purpose, and, therefore, with little real effect.

What better way of disempowering Brian Haw's protest against the state of Britain and its foreign policy than to transform it into an artwork called *State Britain*? For the effect of such a transformation is to redirect the experience of those who see it into one of two channels, both of which work to annihilate the possibility of anything like a protest: those who saw *State Britain* were either intellectually engaged by questions to do with the nature of art, and therefore safely corralled in the "It's not art"/"It *is* art" loop, or so "moved" by the "rare truth" of the work—by a sensation of the liberality of their polity, even by a (disinterested) feeling of the misguidedness of military aggression—that its very *common* submission—that Britain has invaded a country without legal or moral justification—goes

unheard. As if art is too beautiful to be taken seriously, too fragrant to be wasted on the air we breathe.

A museum need not have walls to be a museum. And art need not *quench* your feelings to be oppressive. Because artworks that inspire you with rare truths are not artworks that persuade you with common sense. There is no real tension at all, then, between the very involved "artistic interest" in the most recent winner of the Turner Prize, and the more public, emotional interest in it. For, an art that *moves* you is not a less likely mode of control than an art that puts you into a loop; indeed, the idea of a public being "moved" as it makes its way in the morning to its places of work, suggests the kind of herding to which we might strenuously object if it were done less beautifully, were it dressed, let's say, in riot gear and a hi-vi jacket and held a baton that it was not afraid to apply.

But, a really fulsome sense of the extent to which we are being kettled by art cannot be had until we look, not simply at what art now is and does but also at what it once might have been. As we have described it so far here, the contemporary constitution of art is comprised of a constant see-sawing between the apparently opposite views, of art as an intellectual, an academic, exercise, and of art as a rare opportunity for the public to feel, which views are not in reality opposite at all but rather the seamless route of a very modern preoccupation with disinterest, of a very strategic suspension of instrumentalism and its purposes. It is a route that wraps round us almost entirely, as debate about the nature of art is directed into a to-and-fro movement between the values of originality and morality, of avant-garde experiment and public feeling, and it functions to confine us to a circle of alleged creativity in which creative energies are actually spent out, and without much effect, either in scorning the expectations of a sentimentalized many or in scorning the irrelevance of an intellectualized few. And we will never escape this kettle until we make a well-timed side-step out of it, until we choose the

right moment to jump off the art-ride that is spinning us round and round in circles.

The right moment is the second half of the nineteenth century. During these decades, the elevating and public nature of art so championed by Ruskin *might* have operated without the overriding commitment to a morality of truth that made Ruskin so despise the purposeful, the useful, the merely human; and the idea, Whistler's idea, that art has a value for art's sake alone and is a form of intellectual practice *might* have won the day without that scorn of "outside interests" that Whistler so defiantly maintained.

4

Craft

Let us begin by taking a walk with William Morris, the famous British designer, on a bright afternoon in the 1880s, and make our way out to one of the newly established suburbs of London, built to accommodate the numbers of people who are beginning no longer to want to live inside, above, or even very near, their place of work. The advent of extended street lighting has facilitated this new trend—previously, travel to and from the outskirts had relied upon either the sun or the moon—but its primary motivation is, of course, the enormous growth in industrialized modes of production: one cannot live in or over the factory in which one now works as one of a large, anonymous group, and one will not, if one at all can not, live near its often belching unpleasantness. Because this is for the most part not something that the workers can not do, it has become something that their superiors very quickly *will* not do, as they have begun to trade the hustle and bustle, the mixed economy, of city living, for the quiet and almost entirely residential areas growing up around its margins. And so here we are, with Morris, in a near silent street, lined on either side with the new Victorian villa, a detached residence on a relatively small piece of land, similar to its neighbours in style, but suggestive, in its albeit very qualified independence from the homes around it, of the privileges of the independently rich. There is nobody at all to be seen but gentlemen and their ladies and servants, no tradesmen at their work, no shops selling their wares. *Those* are to be found on the main street, a new invention of the new lifestyle, perfect as a foil for the genteel retirement tucked away behind it. "A beastly place to live in," Morris observes, and quits the scene at once.

The beastliness of these new suburbs inhered, for Morris, in their operating to segregate, not only the population, but also the processes of production and consumption on which life and livelihood relied. Those in the new villas ate, of course, they sat on chairs, dressed in gowns and puffed on pipes, but, contrary to former times, they now felt it desirable to remove themselves as far as possible from the materials and processes that provided their food, their chairs, their gowns and their tobacco. In many cases, this feeling was but an aspiration; not all could afford the move outwards, and even those who could were, by today's standards, still compelled to a very intimate association with the nuts and bolts, and the mechanics, of their lives. But what mattered to Morris was less the fact of people's removal than the attitude towards labour and its materials from which it sprang, and to which it contributed. The sedate seclusion of the quiet suburban street made him shudder because of its disdain of, its effort at retirement from, the stuff and the skills that supported it. Women were learning to be proud of their ignorance of the patterns for sleeves and for shifts; mothers were beginning to boast of not knowing how to care for a child; and men were growing angry if the workings of their households came before them in any manner other than as good fires, fresh flowers, fine meals, and strong sons. In short, it was fast becoming a presupposition of the age that the highest form of human existence knew nothing of the labours whose fruits it enjoyed, and was as removed as possible from the materials and the arts upon which its satisfaction in life so relied.

Morris followed Marx in deploring this separation of labour from life, of manual effort from leisure, of practical work from a more enlightened condition; for Marx, and to a great extent for Morris, it was a tragedy for the labourer, for its effect was so far to demand of him that he labour in isolation—from the product of his labour, from the process of his labour, from those with whom he laboured, and from his thinking and feeling self who

laboured—that the work to which he was assigned came increasingly to be premised upon this isolation, what Marx called this *alienation*. What Morris saw and objected to was an effort to make machines out of men, by taking the life from work to such an extent that manual effort lost its creative and intellectual aspects, practical engagement its requirement of the wisdom gained from experience, and labour any relation to life.

But what Morris also saw and deplored was the tragedy that this separation implied for those in the leafy streets of suburbia, those who had been "freed up" to eat, to dress, to think, to live, without needing to concern themselves with the materials and arts that provided for them. Because what Morris also saw was that an existence "free" of the stuff and skills of existence is one for which possibilities for creativity, for originality, for resistance, are gradually dissolved, not simply because those who are free to think, create, and invent, cannot follow through in practice on what they have thought of, created, and invented (this is a merely circumstantial problem, to do with lack of access to a skilled worker or lack of control over him) but rather that they *cannot think, create, and invent*. The degradation occurs at the level of creative possibilities, and not simply at the level of their realization. In short, Morris knew that creativity, that originality, that thought itself, is a skill and requires practice; one's capacity to *know that* this gown, or that amount of salt, or that shade of paint, or that particular remark, is most fitting is degraded when once one ceases to *know how* gowns are made, or food cooked, or houses built, or conversation conducted. It was not only the worker, then, who was alienated by the retreat of privileged living to the suburbs; that which we now think of as *life*—all of those things that we now regard work as "freeing us up" to do: read, paint, shop, travel, think—is also alienated, from the educative, the enlightening, incubation that is *craft*. The other side of *alienation* is the *artifice* of separating life from utility, the "freedom" to think and act from the exigencies of the everyday

and its purposes.

"Have nothing in your houses that you do not know to be useful or believe to be beautiful," was Morris's golden rule. What a pity. He must rather have meant that we should have nothing in our houses that we do not know to be useful *and* believe to be beautiful: for Morris was devoted to craft, that is, to a mode of living in which the separation of use from beauty, of labour from the rest of life, that was coming to dominate his age, was reversed, and work was undertaken in a manner that did not set at nought the human requirement for aesthetic satisfaction, and aesthetic satisfaction was got from the usefulness of what one saw around one. Certainly, he regretted the conditions under which the swathes of workers in industrialized British cities were compelled to function, but he also regretted the emergent designation of creativity as a higher form of life, best facilitated by a removal from the drudgery of production. The designer of a carpet ought to know how to weave it and ought to weave it, he insisted, and he lived the conviction as best he could. But it was destined to remain a marginal and relatively ineffectual one: capitalism thrives on the constant renewal of demand resultant from the degradation of our capacity to create and to judge our creations; and liberal democracy requires, under its explicit structures of representation and consent, a populace sufficiently deadened to possibilities for creative thinking and the resistance it might inspire, that it needs only the odd time-out in the museum without walls to feel satisfied that it is living a fully realized life.

As Morris would tell us, we have by now grown so inured to alienation and artifice that we are content to regard the work we do merely as a means to a meaningful life, and we are content to derive a sense that life means something from the non-ends-oriented activities, the sun holidays and the city breaks, on which we spend our leisure time. And, in case the pressure of this separation, and then endless round, of means and ends should

get too stifling, there is always the art museum into which to retreat for a while and let off steam, where there are no holds barred, where anything can happen, where nothing is taboo, but where, of course, nothing is to any purpose or of any "interest." It is the equivalent of a dress-down afternoon in the business of living, a paint-balling exercise in re-energizing the "team."

Morris was most famously a designer and maker of interior furnishings, of rugs and fabric and wallpaper. And he was a great admirer of Ruskin. Surprising, perhaps; after all, Ruskin's expectation that art, in its remove from the everyday, functions as a disinterested preparation for the moral seems ill-fitted to Morris's commitment to reintegrating use and beauty in an aesthetic mode of living. And yet, the tradition, in which we have described both Ruskin and Whistler to participate, of valuing the disinterestedness of art, which, at about this time, was beginning to be channelled into the commitment to "art for art's sake," operated very interestingly to reanimate the life of *design*, as the merits of being "merely" decorative garnered support from those who championed the merits of objects of "mere" art. How ambiguously history produces its effects!: the debate about whether or not art ought to be elevating of the many or merely exercising of the few, in its founding presupposition that art is removed from everyday life, lent support to a growing movement dedicated to redecorating everyday life, to redesigning the chairs on which we sit and the carpets on which we walk. Because there is an indeterminacy about the idea that art is a good in itself, which supports both those who regard it as divorced from human purposes, and those whose view it is that there needs no further justification of preferring a beautiful tea-tray to a plain one than that it is beautiful.

Not only this, Morris shared with Ruskin the conviction in the morally elevating effect of exposure to art, and with Whistler the conviction that art is an intellectual effort. For Morris, the having of nothing in your house that was not useful and beautiful was a

moral as well as an aesthetic choice, insofar as the dissolution of the distinction between use and beauty for Morris extended to the dissolution of the distinction between moral and aesthetic concerns; it is not simply "pleasing" to have beautiful wallpaper, or rather the pleasure felt at well-designed wallpaper is also an ethical one to the extent that it is a pleasure that does not reduce the human to mere purposes, but understands a properly human purpose to be more than the mere realization of an end. And, for Morris, the conflation of use and beauty operated also to conflate the "faculties" of thought and feeling: it is not enough that the weaver understand how to weave from a pattern when he can also feel the beauty, of the proposed carpet, of the workings of his machine, of the movements of his arms as he works; and it is not enough that the designer of the carpet feel inspired by certain combinations of colour, he must also know how to weave them into existence and must understand what it is like to live with them too. The idea, which was Ruskin's, that the moral effect of art relies upon its appeal to some higher human faculty of *feeling*, then, was not Morris's; nor, however, was Morris's refusal to isolate aesthetic experience from intellectual activity intended, as Whistler's was intended, to elevate the "artist" at the expense of the public.

How involved it all is, we might think. And so it was, which may explain how the fight for craft got lost in the mêlée. For wallpaper, surprisingly, is a much sought after territory in the modern history of art, and not, as we might think, the inevitable property of the man of craft. Immanuel Kant, *the* modern champion of disinterest, actually chose the patterns on wallpaper (and carpets) as the paradigm of an art valued for occasioning *disinterest* in those who look at it! Admittedly, Kant was, in general, no enthusiast for art, recommending the morally elevating effect of natural beauty as infinitely superior to anything human hands might produce. Only nature really presents us with occasions for disinterest was Kant's view,

because only in respect of natural beauty are we without the knowledge that the object was made to be beautiful; in nature, the fact that, as far as we know (this was the eighteenth century, remember) it might all have been otherwise, the fact that the sun might not have appeared this morning, is the reason that sunrise is so beautiful. The contingency of it, the lack of purpose, the lack of artifice, is what makes it so striking and so uplifting, because it gives a sense of *supernatural* necessity, of *divine* purpose, of *inhuman* artistry. However, if we are to insist on seeking beauty among the objects made by human hand, Kant advised that we could not do better than to look at carpets and wallpaper. For, the patterns on carpets and wallpaper, in their repetitiveness and their uselessness, are about as far as we can get from serving any human purpose: they don't function to depict a powerful king, or mourn a great saint, or recall a mighty victory; they don't remind us of that day we went to the sea or that apple we ate yesterday; they *just are*, Kant thought, and, so long as we can forget their association with keeping the draught from coming up through the floorboards or covering over the unevenness of the plaster on the walls, they can lift us out of the world's round of means and ends and give us a sense of something higher.

Morris was starting further back than he may have thought, then, in looking to design and manufacture wallpaper as a means of supporting the crafts and closing the gap between use and beauty, for even wallpaper had already been conscripted to the cause of defining the beautiful as removed from what is useful. How all occasions did inform against him! And the extent to which they spurred his dull revenge can be shown no more clearly than by the artist deemed most worthy by the jury of the 2009 Turner Prize: Richard Wright, designer and maker, you've guessed it, of *wallpaper*. Wright was a controversial winner, not because his art was "controversial" — there were no dead cows and no used condoms — but because it was not: Richard Dorment wrote for *The Telegraph* at the time, "And here's a sentence I never

thought I'd write about a Turner Prize winner: the result is so damn beautiful you stand transfixed in front of it." The irony!: wallpaper in an art gallery; an object of almost indisputable utility transformed into a work, the transfixing nature of which was purchased very literally at the expense of its function (Wright's work is only temporary, and the room at Tate Britain is no longer "papered" with it). "A beastly business," Morris would have said, as the considerable work of removing Wright's gold designs from the walls of the museum got underway, and effaced not just the winning artwork but also, once again, the relevance of use to beauty.

And *craft*, that creative, that thinking and feeling, mode of living for which use and beauty are warp and woof, just disappears, divided out between art-less works of capital and use-less works of art, between factory floors and suburban walls.

5

Anyone

In response to Wright being named winner of the Turner Prize, Leo Benedictus of *The Guardian* predicted the reaction of "middle England," as "A painter! Hurrah! And he must have worked so terribly hard." For, Wright's patterns were indeed painted onto a wall in the gallery, and the process of getting them there was indeed a technically demanding one, involving the transfer of a design from paper to wall by means of pricking hundreds of tiny holes in the paper, rubbing chalk over its surface, and painting over the chalk with a stiff glue and then gold leaf. "Wright works like an old master," reported *The Telegraph* at the time, presumably referring to the impressive amount of skill required for the production of his work. But also, of course, referring to the very civilized manner in which the work effaces the signs of this skill: positive reactions to Wright's wall almost all shared a claim about the *immediacy* of its effect, describing it as ethereal, irresistible, transfixing, or just simply beautiful. Wright, then, as Kant would have advised him, displayed his genius in a carefully worked, deliberate, and very technical occasioning of an experience of his art as *un*worked, spontaneous, natural; and the jubilation of middle England was at the uninterrupted sensation of beauty inspired by a Turner Prize winner who, for once, had the craft to make them forget that they were looking at something crafted.

Not so Susan Phillipsz, however. Although she claims in interview to be able to paint, recalling her role as the school artist, she never claims to be able to sing. Not, at least, to sing in a trained and technically accomplished manner. Phillipsz sings like we all sing: sweetly at times, with a wavering voice,

uncertain on the high notes and with moments out of tune. Wherein, we may imagine, lies the "public" character of her work: intended for installation under bridges, over the Tannoy systems of supermarkets, or in town squares, it consists of songs sung as the public could sing them, in short, as *anyone* might sing them. Which brings us back to Whistler, whose cross-examination at the trial did not end with Holker's assault on the alleged beauty of *Nocturne in Black and Gold*, but continued to include several questions on the length of time it had taken him to paint it. "How soon did you knock it off?" Ruskin's lawyer asked, to a round of laughter in the courtroom. "Possibly in a couple of days," was Whistler's offhand reply. "How long did it take you to paint that picture?" again he was asked. "I completed the work of that in one day after having arranged the idea in my mind," he answered. "How long did you paint that?" once again he was questioned. "One whole day and part of another," was his response. Like Peter before the crucifixion, Whistler had, so many of those present on the day would have thought, to deny art three times, as three times he admitted to having produced a work in oils, for which he was charging 200 guineas and claiming the status of a work of art the merit of which no artist of culture could deny, all over a period of a day and a half! And, if art had anything much to do with craft or skill, with talent or with technique, certainly he had denied it three times, by the combined effect of his admission of having produced it very quickly and the appearance of the work itself. For, though all in the courtroom were that day looking at *Nocturne* upside-down, it having been carried in that way and nobody apparently having realized that anything was amiss, still, even viewed the right way up, it appeared at the time as if Whistler had done little more than fling a pot of paint at the canvas. The wonder was rather that it had taken him so long! And the suspicion was, that a work that it had required so little skill to produce, that it not only did not succeed in hiding the technicality of its production but shame-

lessly displayed the *lack* of technicality of its production—a work of art, in short, that looked as if *anyone* might have done it—could not fairly count as art.

But Whistler, by 1878, was an old soldier in this fight, having, fifteen years earlier, been among those excluded by the judges of the Paris *Salon* of 1863; the most famous exclusion of that year has since emerged as Manet's *Le Déjeuner sur l'Herbe*, which, much like Whistler's *Nocturne* at the Old Bailey, was judged by the jury of the *Salon* effectively as undermining the art of art. At least Whistler had bothered to fling paint over *all* of his canvas; Manet had gone so far as to leave some of his actually showing through! On the other hand, Manet's work was also *more* acquiescent than Whistler's, to the requirement that art take time and result from the exercise of talent and technique; true, in the background is a very thinly painted female figure, through which the weave of the canvas is clearly to be seen, but in the foreground is a fully realized nude, with the generous flesh so characteristic of Classical representations of the gods, and rendered with the kind of skill that "middle England" so appreciates. Which makes Manet's *Déjeuner* an intriguing sort of fulcrum, a condensed transcription of Whistler versus Ruskin in a sense, in that, within the one frame, there is exhibited both the "genius" of tradition and the effrontery of the modern, both the skilled painting of divine truth and the apparently careless concern with painting itself. Small wonder, then, that Manet is often named the father of modern art, in that his work seems very explicitly to paint the parameters within which modern art has unfolded ever since, juxtaposing the traditional expectation that art elevates the public via its beauty and its truth, with the emergence of an interest, an "artistic interest" as Whistler calls it, in the conditions of art itself.

But are we taking Whistler's version of all of this too seriously? Is there not something else going on than art's retreat from the elevating universality of moral truths to the purely

"artistic interests" that Whistler describes his work as addressing? Far from a retreat into an elite intellectualism, is there not rather an advance towards the masses and their concerns? After all, just as we might interpret Phillipzs's work as responding to the public spaces in which it is mounted by a display of effort that is unwilling to alienate the public with the feelings of awe that, say, the sight of a Titian painting might occasion, we might describe Manet as working to respond to the very public nature of the *Salon* also by the deliberate display of an effort that looks, well, less than genius. The time was certainly ripe for such a move: the *Salon* was not just "public" in the manner of Tate Britain; at the height of its influence, 23,000 people passed through its doors every day, with one million of the estimated 1.4 million inhabitants of Paris attending at least once during its six-week run. It is no stretch of the imagination, then, to attribute to Manet a determined response to this new, very public, time for art, and to describe that response as a move from the inspiring, but distant and didactic, art of the past to a much more involving, more inviting, more *human*, art of the present. "*Anyone* can do this!" Manet's *Déjeuner* is saying. "Look! Simply get a canvas similar to the one you can still see in the background of this painting, and apply some paint in the stages that I have left unconcealed, for you to look at." In which case, it is no coincidence that "middle England" continues nostalgic for the art of the past, for this new way, this human way, this anyone-can-do-it way, suggests a power for the people like never before.

And this is precisely what Joseph Beuys (of the basalt blocks) kept telling us, when he wrote on behalf of the do-it-yourself "Fluxus" movement in art, that the still-surviving interest in traditional art is utterly undemocratic, a refusal on our part to assume the mantle of creativity held out to us by so many modern artworks, and the result of a curious desire to remain in thrall to the grand old truths, and the grand old indentures, of the past. Every living person can and must be an artist, Beuys tells

us, so that creativity can "turn into a politically productive force, coursing through each person, and shaping history." Only once we accept this, accept both the freedom and the responsibility it implies, will democracy really begin to be possible. Seen in this light, Manet emerges as a man of the people, as an artist who availed himself of a sudden explosion in public interest in artworks to convince all who would look at his paintings that now was a time to finally relinquish the hierarchical structures of history and take advantage of the freedom—to think, to act, to speak, and to live—that was our new birthright.

But what kind of freedom is this, after all? And how democratically does it really function? In 1955, Georges Bataille wrote a short account of Manet's work, in which he appears at first to describe the painter in precisely the terms we have just suggested, as at the cusp of an unprecedented promise of sociopolitical freedom. Before the time in which Manet painted so presciently, Bataille writes, "art had been the appanage of kings and princes" and "its mission had been to express an inordinate, unexceptionable majesty which, tyrannically, unified men." But of this majesty, nothing now remained, Bataille continues, so that painters who had once been the mere servants of a higher truth (be that truth, kingly or divine) emerged as their own masters; "the painters who had once been 'artisans' were 'artists,'" he says. Contrary to Morris's elevation of the craftsman—the artisan—as the type of a fully human existence, Manet, so Bataille describes it, demonstrated the liberating effect of creativity as *art*, that is, creativity free of imposed purposes, creativity with neither agenda nor *interest*. Only such a mode of creativity can exploit the loosening of traditional structures to truly level things out; only such a mode of creativity is for all.

But, at what expense does art cease to attempt to galvanize the public around universal truths, still define itself over and against the artisanry of interested projects, and still attempt to address *us all*? At the expense of *us all* is the short answer,

because such an art, in being for *anyone*, is, in the end, for the very very few. Of what he describes as Manet's undercutting of painting's Classical styles and themes, Bataille writes: "Thus was majesty retrieved by the suppression of its outward blandishments—a majesty for everyone and no one, for everything and nothing." For Bataille, the glory of Manet's work was that it set at nought: not only the great truths of tradition—here was no effort to represent the ideals of love, loss, life, and so on; not only traditional social and political hierarchies—here was no glorification of a nation or a king; but also the more everyday reflections of such interests—here, Bataille triumphantly observes, were no merely populist representations of mundane events and the people involved in them. But wait. Are Manet's paintings not filled with such events and such people? Is their subject matter not precisely the opera, the park, the café, the brothel, and men dressed in the plain black attire that was the fashion of the day and women behind the bar serving them up what they need? Oh, to be sure, Bataille admits, "to some extent every picture has its subject. But now these have shrunk to insignificance. They are," he tells us "mere pretexts for the painting itself." Men in top hats and women in costumes, there certainly are a-plenty, he allows, but what was great about Manet was the "active, constructive indifference" to them that his paintings performed; the "frivolity" of human existence was of significance only insofar as it helped to expose the "profundity" of "painting itself."

And so, the tables have turned: an art that had seemed truly for the people is taken up as an art to, as Bataille describes it, "suppress and destroy" them; an art that had seemed to celebrate the freedom implied by a general license to create is taken up as an art concerned to establish freedom only for art itself; an art that had seemed to champion the interests of the many merely clears the ground for the "artistic interests" of the few; an art that became something anyone could do was an art that no one but the very few could look at, care about, or attempt to understand.

How misguided was Beuys!, imagining democratic possibilities to inhere in a mode of creativity that takes its cue from art; his idea that anyone could be an artist had long been co-opted by "artistic interests" so anathema to the conditions of everyday existence, that they began by juxtaposing those conditions with trappings of the old truths all the better to annihilate both, and continued into the twentieth century by dispensing, slowly but surely, with the "arts" of art: the rules of perspective, the figure, the brushstroke, the grid, the canvas, the museum, the object, and the artist, all were first highlighted as mere artifice, mere human contrivance, in order then to be eliminated for that very reason. That *anyone* could make art was the reason, it turns out, for art no longer wanting to be art. How misguided was Beuys! To call for everyone to begin to practice their own suppression and destruction!

Arthur Danto, the American critic and philosopher of art, is perhaps the most famous contemporary to tell this story, of an art full of arts that became an art without art. It is, according to Danto, a story that culminated in the 1960s, when Pop artist, Andy Warhol, exhibited in the Stable Gallery, New York, faithful reproductions of the shipping containers of various products—breakfast cereal, tinned fruit, and Brillo pads. Here, at last, Danto tells us, art came to an end, as "artistic interests" trumped all those other interests to which the arts of art had been oriented. Here at last, art could look like anything at all, and only those trained and interested in the nature of art were expected to respond. The Brillo Boxes were truly something anyone could "make"—they were also mass produced and could, with very little effort, be acquired and submitted for exhibition—but they represented the perfect fruition of an art that only a very few could appreciate or understand. Interestingly, as Danto recalls that exciting moment in the '60s some decades later, he tells us that he would not have been in the slightest bit interested in being an artist at that time, but that it was very exciting to be one

who was "interested" in art at that time. Why? Because the arts of the artist were no longer required; only the thoughts of the critic were needed.

What began in the Paris *Salon*, then, was the simultaneous advance of the arts into life, as achievements of which anyone is capable, and retreat of art from life as that of which only a few, educated in the history and theory of art, are capable. Why so public a forum for the beginnings of this retreat? Because it needed the public and their common concerns to enact a refusal anymore to serve God and King, yes, but also because art needed at first to have some pretext or other for its new mode of existence. Not everything could be done at once; it was not possible for Manet all of a sudden to display a urinal or a Brillo box container. Such objects would never have been registered as art at the time. No, just as Manet needed to paint a Classical figure for the modern subject and style of his paintings even to be seen, so also Manet needed to paint modern places and people for his scorn of such things, compared with his concern with the conditions of painting itself, to be seen and taken up as of interest. He needed a foil, in short, a *pretext*: and the extent to which our Classical nude's exposure to the public's eye is achieved by seating her next to some very modern men at their picnic, is mirrored in the extent to which those very modern men's exposure to a few discerning eyes is achieved by their being painted in odd perspective, in thinly applied paint, grouped together apparently without concern for the balance of the picture, and so on. For these are mere common people, and the arts that might have represented them are mere human arts; it was the fate of both to be eliminated in what was, after all, art's *continuing* pursuit of some more-than-merely-human truth. For, as Whistler shared with Ruskin at least a commitment to the disinterestedness of art, so Modern art shares with its Classical past the contempt for mere human contrivances that made those desirous of elevating the public concerned to hide the techniques

of their trade, and those interested only in "art itself" concerned to scorn, one by one, the arts with which only an unsophisticated public could be satisfied. The "majesty" that Bataille describes as having kept creativity in such bondage for so long was not overthrown by new developments but rather, as he says, "retrieved" by them, with only its "outward blandishments" dispensed with.

And there is, if Danto is to be believed, no way back. Art has, he says, stepped beyond the pale of history, to the extent that it is no longer possible to identify any particular kind of object or style or occasion that is necessary to art; art, in short, exists only conceptually, that is, only in the minds of those interested in art. "Do you not think that anybody looking at that picture might fairly come to the conclusion that it had no peculiar beauty?" the Attorney General asked Whistler of his beleaguered *Nocturne.* "No artist of culture would come to that conclusion," was Whistler's contemptuous reply. For anyone can throw paint at a canvas, but the difference between Pollock and paintballing is understood only by the "cultured" few.

When Ruskin accused Whistler of flinging a pot of paint in the public's face, he was more in the right than he could possibly have known. For the provenance of contemporary artworks is such that, though seen or heard by many, they can now, by definition, be of interest only to those sufficiently removed from everyday life to be bothered by questions to do with the nature of art. And, in the process, the *arts* have fallen away, victims of their systematic identification, first with outdated moral and political ideals, and then, simultaneously, with an "undemocratic" desire to be alienated from creativity and a mere "common" contentment with mere human contrivances. So that, though many may hear *Lowlands Away* played under the bridges over Glasgow's River Clyde, the effect is almost entirely truncated; after all, we could hum it better ourselves, and, anyway, it's *art*, you know, which makes no difference to anyone.

6

The Human Touch

But Manet has so far here been badly served, by too carelessly identifying him with the tradition of his influence and interpretation. Manet was not the artist Bataille so admires, nor was he a comrade in Whistler's arms. After all, it's a very complex story, the one that tells of painting everyday scenes with everyday people in everyday clothes for a fast-becoming everyday scene with everyday people in everyday clothes, in order *not* to paint everyday scenes with everyday people in everyday clothes for an everyday scene with everyday people in everyday clothes. So complex, indeed, that we ought, perhaps, to consider the simpler story first.

And it goes like this: The mid-nineteenth century saw the Paris *Salon*, an event that had been taking place already for well over a century, explode with popularity, with people from all walks of life thronging to see the paintings that were crowded together on every inch of available wall-space in the gallery. And in this explosion, Manet saw an opportunity for *something different for painting*, in short, for a reciprocal relationship between painting and everyday life, between painting and the "man on the street," to which the extraordinary publicity of the *Salon* gave unwitting plausibility and which might, just might, have dislodged the expectation, both traditional and modern, that good art is disinterested art, that good art is inhuman art, that good art is at a remove. Certainly, in pursuit of his new idea, Manet did seek to ease the pressure on art to be classically beautiful and true, but he did not do so in order simply to pursue a modern merely "artistic interest," as Bataille would have us believe; no, Manet's idea was still to address the people, but "the

people" understood as the throngs of Parisians likely to attend the *Salon* in the 1860s and decades following, rather than as a uniform mass with universal faculties for good and evil. His idea was still to be enlightening, but not with the shock and awe techniques of Ruskin's kind; instead, he sought to give an account of everyday life and see what came of it. Certainly, in pursuit of his new idea, Manet began to depart from the verisimilitude of traditional artworks: but he did so in order to encourage his audience to stop looking 'out there' or 'up there' for the meaning of his paintings, and most definitely to pre-empt their simply stopping looking at paintings altogether; Manet wanted his audience to begin to respond to his paintings, as forms of address in which *they* are involved, in which *they* are participants. And certainly, in pursuit of his new idea, Manet made one of a cohort of artists actually excluded from the *Salon*, on the grounds that their work was not good enough, or not art enough; but the alternative *Salon des Refusés* made it possible for the "man on the street" not only to look at but even to purchase what, in the official *Salon*, was for the most part painted for the taste and the purse of the state. If Beuys was looking for a model for the democratic, surely here would have been a new idea to suit!

But there are, of course, some pictures to go with this story. There is Manet's *Olympia* from 1863, which effectively repaints Titian's *Urbino Venus* from over three centuries before so that our goddess of love, rather than languishing voluptuously, is, though reclined, alert, looking directly out from the painting, perhaps at the *client* whose flowers the maid has caught in her arms. More than perhaps, for in place of the rather flaccid, sleeping lapdog of Titian's work there is now, at the end of Olympia's bed, a lean black cat with back arched and tail erect, to confirm the sexual implications of our goddess's posture and expression. Then, some ten years later, there is *Le Chemin de Fer*, in which we are faced with a woman, seated before a railing through which a

young girl with her back to us is gazing at a passing steam engine: a governess or nanny and her charge, perhaps. This woman, too, stares straight out from the canvas, apparently having also been intruded upon, and distracted from the book that now lies neglected on her lap; she is not so complacent as Olympia, though, whose pert composure contrasts with the blush that has spread across our governess's cheeks, a modest counterpoint to the erect tail of Olympia's lean black cat. It *is* a blush, for it cannot be the cold (the little girl wears only a light sleeveless dress) and it cannot be rouge (unless the governess applies it with an Olympian lack of modesty that is belied by her dress and demeanour).

What can all of this mean? What is Manet doing, with his pert goddesses and prudish governesses, staring straight out from their paintings? He is trying to interest you, is what he is doing, trying to get you to look at his work. The women stare...*at you*. The cat hisses...*at you*. The governess blushes...*at you*. Not only this, Manet is trying his best to paint as someone...*like you*. The great unspoken condition of a painting like Titian's *Urbino Venus*—another of those merely "human" conditions that such paintings are made and seen in order to ignore—is that its painter, to depict divinity, had for hours on end to stare at naked humanity! And Manet tries to show it. The pallor of his Olympia is somewhat sickly and her figure less than full; here, there is no unearthly tone and no folds of flesh to efface the model who was looked at so carefully for so long, and whose increasing stiffness and unease are embodied in the resentful arch of the black cat. And, as X-rays of *Le Chemin de Fer* show, the blush on our governess's face is some of the most layered and worked-up painting that Manet ever produced. He spent hours on achieving the effect, demanding from his model extended periods of exposure and subjecting her to such scrutiny that she grew more and more startled and embarrassed, her face gradually suffusing in the colour that so implicates you in the painting when you look

at it.

But, who is this 'you'? Not you, is the answer, which summarizes the idea for something different for painting that Manet so valiantly attempted to paint. Unlike the "man on the street" in 1860s Paris, you have not been in the habit of frequenting the kinds of establishment in which Olympias ply their trade; that is not in the nature of infidelity anymore. And, unlike the "man on the street" in 1870s Paris, your gentle but unexpected approach would not in itself be likely to produce a blush across the face of a young woman with her book and her charge. And she wouldn't be dressed like that, or undressed like that; and the room wouldn't look like that, and the train wouldn't steam like that. And, what is crucial to acknowledge, is that Manet knew it, and revelled in it, and cared less for engaging the approval of the "you"s of posterity—never mind the "you" of universality—than he did for addressing the "you"s of his time. Bataille reports that, on Mondays, when a pose was settled on for the week's work, Manet invariably got into a tiff with his models. "Why the devil can't you be natural?" Manet used to exclaim. "Is that the way you stand when you go to the grocer's to buy a bunch of radishes?" For Manet's "man on the street" was not just *anyone*, you know; it was *you*.

But Manet's vision for something different for painting was not catching on; you would not, at the time, understand yourself as implicated. Wedged into the crowds at the *Salon*, you looked to see precisely the opposite, to see that which was beyond you, or above you, that which set the contingencies of your life or any life at nought and raised you up because of it. And you were inevitably disappointed. And so Manet got desperate, and made a last frustrated effort to get you to look at, and not beyond, his work; the result: *Un bar aux Folies-Bergère*. A decade had passed since the appearance of *Le Chemin de Fer* and Manet's health was in decline. He was 49 years old, and had, it turned out, less than two years to live. He had spent his career in addressing people

who would not listen, who would not *look*. Time for desperate measures. Time to *paint in* his idea for something different for painting. Time to borrow a little of the didacticism of the past in order to jolt you from your stalwart belief in the inhumanity of art. *Un Bar* also features a young woman staring directly out from the canvas, a barmaid with melancholy eyes and uncertain expression. But you are not left in any more doubt that it is you on whom she rests those eyes, you for whom that hesitating acquiescence is intended. For, there you are!: no longer merely implied by startled cats and blushing cheeks, but actually reflected in the mirror behind the bar at which the woman is serving, and serving *you*.

But wait a moment. The story is a little less straightforward. The barmaid, like her precursors, does look directly outwards from the middle of the painting, at you who stands before her in front of the middle of the painting. But, if that is really you—that man dressed in the fashions of the day and reflected in the mirror behind the bar—then your reflection ought to be directly behind the barmaid and therefore barely visible in the painting. As it is, if it is you, your reflection is misplaced, very visibly to the right of the picture. So it can't be you? But, the man reflected in the mirror is reflected as standing directly in front of the barmaid, which, if that is where he is really standing and if he is not you, would place him between you and the barmaid and make her more or less invisible in the painting, effectively by blocking your view of her. And it would still leave unsolved the placement of his reflection, which should still be—if he is, as he is depicted to be in his reflection, standing directly in front of the barmaid— directly behind the barmaid and therefore also blocked from your view, both by the barmaid and by himself. In short, the reflection in the mirror simultaneously places you very explicitly before the barmaid, as the one to whom her expression and services are addressed, and, also very explicitly, makes it impossible that you are standing before the barmaid and the object of her attention.

Has Manet made a mistake? Has he got his laws of perspective so wrong? Quite the contrary, as he takes some pains to point out. The mirror behind the bar—which appears to cause Manet such trouble—seems at first glance to be placed in parallel with the bar counter and the line of the canvas. But other clues—the reflection in the mirror of the left-hand edge of the bar, for one thing—suggest that the mirror is actually turned clockwise on its axis. In other words, Manet very deliberately and very carefully incorporated two different perspectives into his painting.

What was he hoping to achieve by this? Quite literally: he was hoping to show you that you are reflected in his work. You, who stand before his paintings, are part of his paintings, a participant in them. And it was not enough to show this "truly." For, by showing you to yourself "truly," you would have been barely visible, your reflection almost effaced by the figure of the barmaid. And Manet had been too many years in failing to get you to respond, to trust to the effect of that, too many years in witnessing your expectation of your effacement by painting to trust that your almost entirely effaced reflection would do the job. So, he placed you in full view. But that too would not have been enough. For, you would not have suspected a man dressed in the black frock coat and top hat of the day to be of any relevance to your higher capacities for beauty and truth, which you expected the paintings you looked at to speak to and improve. So, he placed a man dressed in the black frock coat and top hat of the day in full view, *as standing directly before the barmaid and, therefore, of the painting*. It is you, and you as you are, in your black frock coat and top hat. But it is, of course, also not you, not, that is, if you are not dressed in a black frock coat and top hat, in short, in the fashions of the day. The impossibility of the man in the mirror being you is confirmed as well as contradicted by the painting; you are no longer the person with whom Manet was in dialogue, for he was not in dialogue with just *anyone*.

And that it was a dialogue, with his times and their people, that was Manet's idea for something different for painting, is also left in little doubt, is also *painted in*, by this extraordinary painting that so explicitly, so frustratedly, and ultimately so unsuccessfully, tried for the democratic vision that Manet had for his art. Manet was done with trusting to the effect of very human skin tone and evidently worked-up blushes to indicate that it is he, the painter, who, like you, stood before his canvas to say something. No, this time he painted himself into the painting as well. Or at least, he painted in a painter. The man reflected in the mirror, the "man on the street"—you, but not you—was modelled in Manet's studio by a painter of his acquaintance; you, but not you, was also Manet, for Manet, like you but unlike you, was a man on the streets of his time. This painter of his acquaintance was, so it happens, called Gaston *La Touche*. The irony! Manet: a painter with what we call "the human touch," destined to be "raised up" out of his times and its people by the purely "artistic interests" of those who claim him as the founder of modern art.

Part of this reading of Manet's work as an effort to encourage participation in painting is owing to the French art critic and philosopher, Thierry de Duve, who, as curator of an exhibition held in the *Palais des Beaux Arts* in Brussels between November 2000 and January 2001, and dedicated to "one hundred years of contemporary art," gives an interesting reading of five of Manet's works. Concerned to show the manner in which Manet fathered a new kind of art, de Duve offers a very lively account of the "pact" into which the painter and the viewers of Manet's paintings enter, and which, de Duve claims, works to undermine the expectation, still very much abroad in Manet's time, that paintings efface the painter and his interests and skill, and address only that which is universal, only that which is inhuman, in those who look at them. But what follows, in de Duve's account of the paintings exhibited in Brussels that year, works

very well to show how Manet's "pact" after all went unsigned. In his genealogy of the modern art that arises out of Manet's attempt to paint for his audience, de Duve arrives at last at the 1960s and names Robert Ryman's tiny canvases, daubed in various ways with white paint, as the inheritors of Manet's idea for something different for painting. Anyone who responds to Ryman's work merely as another version of painting's commentary on painting (another version of an art with "artistic interests" only), according to de Duve, drains it of "its human content and its ethical dimension." For, Ryman's concern is not with painting itself but, de Duve would convince us, with the practice of "incarnation in the second person" that Manet began. It is touch—"in the literal sense," de Duve tells us—that is Ryman's concern.

But, one wonders what has happened to the "human content and ethical dimension" of Manet's work, if it has been so reduced to the "literal" "incarnation" of "the human touch" that Ryman's work explores. Ryman, de Duve explains (and it is easy to believe him), makes no effort to please his audience; he has no desire to touch *through* his painting. On the contrary, de Duve says, Ryman does homage to tact, literally, "explicitly," "autonomously," by touching his paintings with paint. In effect, then, the "pact" that Manet put in place, was, on de Duve's account, an agreement that painting is not only about seeing but also about touching, not only about colour and form but also about texture. It is still the case, however, that this new "pact" follows the same trajectory as the old one, giving rise to a story of those with increasingly artistic interests only. Saying that Ryman "works the touch to get it speaking about the touch" is, according to de Duve, tantamount to saying nothing. We could not agree more. But saying, as de Duve says, that Ryman works the touch to give expression to the human, is to reduce the human to an abstraction and to leave far behind the "incarnation," in black frock coat and top hat, of Manet's "human

content," to leave far far behind the human touch that Manet essayed with so much to lose, and so much now lost.

How much now lost is evident all around us: in the large, cool, white, and mostly empty spaces in which what we call art is now displayed; in the very limited demographic ever likely to enter such spaces; in the almost total identification of art with an artworld and corresponding almost total loss of art from any other world: the world of home, the world of work, the world of play, the world of life. But how much now lost is most painfully evident in that one corner of the artworld that would, in name at least, re-intersect with the worlds from which it has removed itself, that would try once more to arouse our interest, to get us all involved. In July 2009, as part of the "Fourth Plinth" project that commissions artworks for the fourth plinth of Trafalgar Square, Antony Gormley mounted his *One and Other*, an artwork comprised of the participation of almost 2,500 members of the public, "plucked from their daily lives, or from the street" as Gormley described it (not quite: they had to apply first, and were then chosen at random by computer), each of whom were to be hoisted up onto the plinth in order there to spend one hour, doing anything they liked so long as it was legal. "I think it's fantastic," said Mayor Boris Johnson in his speech to open the work. "It's about capturing art for the people. It's about democratizing art." The first person on the plinth was, it turned out, something of a surprise: Stuart Holmes broke through the barrier and hoisted himself up, in order to stand with a banner condemning actors whose characters smoke on screen. Though perhaps the person most truly "plucked from the street," organizers increased security around the plinth once Holmes had descended. The second person on the plinth was Rachel Wardell, who held a balloon in support of the NSPCC and who reported that, once up there, "you feel very removed from what's going on." The third person on the plinth was Jason Clark, who spent some of his time taking snapshots of the crowds gathered below

him and the remainder just standing with his hands in his pockets, causing commentators to express concern that Gormley's work would collapse into the mundane and lose its energy. The fourth person on the plinth....

But, perhaps we have seen enough. Enough, at least, to feel that Manet's idea for something different for painting, his idea of addressing "the man on the street" as himself "a man on the street," his idea for a mode of existence for painting appropriate to the unprecedented democracy of the Paris *Salon*, has fallen off indeed if *One and Other* is the contemporary inheritor of the "I"s and "you"s that Manet had in mind for art. It is surely no coincidence that the first three "participants" in Gormley's work were: one protesting against virtual smoking, one whose overwhelming sense was of being at a remove, and one who swayed between the attitude of boredom and the uncritical voraciousness of the tourist who looks at everything and sees nothing. For this is the mode of existence of art in our times: only ever unreal, only ever removed, and only ever appearing either irrelevant or "monumental" in the eyes of those who bother to notice it. And it is not at all strange that an artwork intended to be "democratizing" should so immediately reproduce these very undemocratic conditions, for they are sufficiently ingrained that even the human touch is made inhuman, and even participation by the people made alienating of the people. Why this should be so is very quickly summarized. De Duve favourably distinguishes Ryman from those "careful craftsmen" who seek to address an audience *through* their painting; Ryman, de Duve tells us, does not treat painting merely as a medium but as something in its own right. And therein lies the kernel of the kettle that is art in our times, for its defining move is to make the medium into the message and, thereby, to silence the message. If one would, as Manet thought he might, touch one's audience, you can be sure that art, in moving quickly to honour *touch itself*, will disarm any such possibility; if one would, as Manet thought he might,

encourage one's viewers to think of themselves as involved in one's paintings, as at stake in them, you can be sure that art, in moving quickly to honour *involvement itself*, will annihilate any such possibility. It is in this sense that Manet's new idea has never really had its chance: in painting his Venus with unhealthy pallor and ungainly limbs, he had sought to suppress the tradition of making and looking at art in order to gain exposure to something divine; but the humans in whom Manet was interested went very quickly the way of their gods, as art replaced the traditional homage to divinity, with the modern homage to art itself for which Manet's human touch was only ever a temporary pretext.

The Telegraph's Rupert Christiansen reported of Gormley's *One and Other* at the time, that it struck him as a rather sinister reminder of execution by guillotine, as, one by one, at regular intervals and without reprieve, members of the public were isolated from the crowd in which they stood, escorted by security guards to the bucket of the hoist, and placed on a pedestal for all to see. And, just as the guillotine, which was set up to annihilate the alleged divine right of kings, in the end killed far more citizens than it did their rulers, so, tragically, the idea for something different for art to which Manet devoted his career has ended in erasing far far more human interests than divine. In October 2010, an artwork by Ai Weiwei, consisting of 100 million little porcelain sunflower seeds covering the floor of the Turbine Hall of Tate Modern, was advertised as an occasion for members of the public actually to become sculptors, by stomping and rolling around in the seeds to change their formation. Three days after it opened, however, the public was barred from partici-pating in the work, after some reported suffering respiratory problems due to the amount of dust generated by their sculpting activities. How unwittingly apt of the Tate's health and safety officers! For art *is* bad for your health: participation in art, bad for participation; democratic art, bad for democracy; and the art of touch, bad for the human touch.

The "Fourth Plinth" project's commission for 2012 is a sculpture entitled *Power Structures, Fig. 101.* This fourth plinth is revelatory: artworks as power structures; art as the guillotine of the modern age.

7

Trafalgar Square

Trafalgar Square is proving so telling a location that we ought to linger there a little while yet. For long enough, at least to take note of one who, during the early months of 1845, did anything but linger in the Square but used rather to cross it at great pace, headed for the steps of the National Gallery on its north side. The man in question is Charles Frederick Worth, soon to be world-renowned *couturier* but as yet only a lowly draper in the employ of *Lewis and Allenby* on Regent Street. He has more than likely been assigned to some errand by his superior at work and has managed, through its speedy despatch and a skipped lunch, to save enough time for his favourite occupation of looking at the vast number and range of pictures, in such a variety of styles and treating of such diverse subjects, exhibited in the museum at Trafalgar Square. To the eyes of this provincial young man, it seemed an exhibition that put to shame the dull regularity of those innovations in dress and décor serviced by the firm in which he worked: such a range of colour and cut as was suggested by the concentrated and indiscriminate juxtapositions of the National Gallery's display made the young Worth all but burst with frustration at what came increasingly to appear to him as the lugubrious conservatism of contemporary fashion.

Thirteen years later, in 1858, Worth, now living in Paris, established *Worth et Bobergh*, his very own house of fashion, soon with its very own custom from court: the beautiful and sociable Empress Eugénie wore its gowns, and nothing more could be wished for than that. Except, of course, a constant supply of business and the income it brings; but this was assured by the contemporary enthusiasm of the French for lavish parties at

which guests were expected to appear in fancy dress. *Worth et Bobergh* flourished: his exposure to the variety of historical styles of dress during his lunchtimes with the pictures in the National Gallery at Trafalgar Square had provided Worth with an almost endless stream of ideas for costumes; very quickly, the House of Worth was *the* place to shop. But not for this reason alone. French fashions at that time were, aside altogether from the dress code at parties, just very *fancy*, that is, elaborately trimmed and fussy. And Worth saw his opportunity: to establish his fashion house, not simply as the one most adept at producing fancy dress, but also as the one most associated with *simple* dress, that is, with dresses whose quality of cut, whose modest but perfectly executed lines, whose glove-like fit, would in time utterly trounce the bias in favour of showy, overly elaborate attire. This had always been Worth's real talent: previous to establishing his own House, he had worked at the renowned Parisian silk mercers, *Gagelin*, where he had been used to make a few plain dresses to be worn by the model who was employed to display the off-the-shelf hats and shawls that customers came to buy. This was new; dressmaking had previously been the preserve of women. And this was revolutionary; for, the customers who came to *Gagelin* to buy a shawl or a hat very quickly wanted to buy the dress that was worn by the person who was modelling the shawl or the hat, for the dress was so well designed and so well fit that no sumptuous accessory could distract the eye from its superior make. It was no time at all before nothing less than a perfect and relatively unadorned fit was considered tolerable by those who could afford the luxury of such discernment. And so the house of *Worth et Bobergh* was assured of its success, by having monopolized the market for fancy dress and created a market for simple dresses.

But there was more than one side to simple dresses, as there was more than one sense of fancy dress. Worth's designs may indeed have been remarkable for their simplicity, and for the

finely honed craftsmanship with which that simplicity was realized, but the manner in which, and the pace at which, he made the *modes* of simplicity to change were far from simple, but as busy in their way, as *excessive*, as the over-trimmed gowns that his talent for simplicity had made so undesirable. Previous to the success of *Worth et Bobergh*, fashions had changed slowly and fitfully, mostly in line with the contingencies of social, political and economic conditions. The "empire line" so familiar to us from screen adaptations of the novels of Austen, for instance, came into vogue as part of a much more general Enlightenment revival of the Classical; the fall of these gowns—straight down past the curve of a woman's hips—was reminiscent of those Grecian columns whose lines had a beauty that seemed at the time true. And even the ubiquity of the *cage crinoline* during the 1860s—for which Worth is usually, and not entirely accurately, named as responsible—had its roots, both in women's desire to free up their legs for ease of work and exercise (Empress Eugénie was a great walker) and in various developments in the manufacture of steel. But changes in styles of dress had also been constrained by the *domesticity* of their manufacture, with women themselves, or their regular dressmaker, working more often to update an old gown than to begin a new one. Certainly, the sudden glut of affordable material resulting from the rise in its industrialized production contributed to the loosening of these conservative practices, but, if it did, it contributed to a pattern of changing fashions, and a new set of values for dress, that all but eliminated the staying effect of more general conditions and more local capacities, that all but cut ties between dress and anything else. The house of *Worth et Bobergh* began to ring the changes in fashion with such rapidity and regularity, that only change for change's sake, that only creativity as an achievement in its own right, that only the fruitful combination of "artistic interests" and profit, could have been the main stake, as Worth reprised his earlier servicing of the fad for fancy dress parties by

rummaging through the wardrobes of history for ideas for colour and cut, but this time in order to provide himself with a constant fund of material, not for a single outfit or occasion, but for a stream of substitutions of one fashion for another, which had neither rhyme nor reason but only an ever-diminishing set of social and economic constraints to limit it. Worth's biographer describes his fashion house as "not a dress shop but a palace of costume," and indeed *Worth et Bobergh* came more and more to resemble the National Gallery on Trafalgar Square: filled to the brim with details from the past, plucked from their time and place, hung up flat, and juxtaposed without judgment. With Worth, dress was fast becoming a very profitable art.

And Worth began to dress the part, abandoning the conventional attire of the gentleman—at that time, nothing but the sombre black suits and tall black hats that Manet liked so much to paint—in favour of the beret, the bow, and the folds of rich velvet that made him look like Rembrandt. What a very curious development! On the one hand, Worth evidently wished to establish himself as more than the "mere" artisan that previous dressmakers had been seen as; he was an artist and was staking his claim to this in the manner he knew best, that is, by changing his clothes, by dressing like an artist. On the other hand, in so doing Worth was himself rejecting the regular round of convention and invention that had come, largely in his hands, to dominate fashion; he was adopting a mode of dress to distance himself from the changefulness of fashion and ally himself with the constancy of art. The dressmaker was dressing in contempt of his trade; the artist was at odds with his art.

How are we to understand this curious wardrobe crisis? Well, it is no coincidence that Worth's choice of garments to wear was also that of a movement just then abroad in England, and itself an organization with no small amount of ambiguity at its core. Begun, during the 1860s, as a commitment by artists like Dante Gabriel Rosetti to what they called "artistic dress," it at first

attached itself very explicitly to the value of handiwork, of quality materials, and of purity of design, and advocated a mode of dress reminiscent of the flowing robes of Medieval times as the most natural clothing for the human form and its functions; Rosetti's portraits of William Morris's wife, Jane, depict their subject as attired in precisely this manner. In the 1880s, however, this commitment to "artistic dress" grew into the Aesthetic Dress Movement, which, although it continued Rosetti's contempt for the constant and trivial changefulness of contemporary fashions and even with Rosetti's preference for flowing lines and loose fit, came increasingly to devote itself to a more refined, disinterested, pleasure than that available from an emphasis on craftwork and to interpret flowing lines and loose fit as an appropriate revival of the Classical rather than the Medieval! Worth, then, was in many ways both a cause and a sign of his times, with their gradually developing chasm: between the truth perceived to inhere in art and the application and interest of the craftsman, yes; but also between the artist *and* craftsman, and the "man on the street," the latter distinguished by neither art nor craft, but merely subject to that endless round of trivial changes that made him fashion's victim.

And the upshot of it all was a great, and as yet unretrieved, loss: on the side of production, of *craft*; and on the side of what is now called "consumption," of *taste*. These days, fashion houses no longer demand profitability from the "creative" end of their business, that is, from *couture*, which now functions as a symbol of status whose excess, whose distance from anything that might actually be worn, is expressive of the profit that mounts up in the rest of the business. But what this has done is almost to define *couture* as anathema to dress, as if its contrast with the *"prêt-à-porter"* side of the fashion business is purchased with, not its "tailor-making" clothes that are fit to wear in a way those ready-to-wear never could be, but rather its making clothes that are not fit to wear at all! This side of the tragedy is Worth's: the first

couturier, in construing the highly talented crafting of clothes as an art, began to lose from the "creative" side of the production of clothes all association with craft, as the *couture* end of fashion has defined itself more and more against the practice of dressing. Those who sit in the front rows at fashion shows are as likely now to see something to wear as those wandering around the vast spaces of contemporary art museums are likely to see something to use.

But the other side of the tragedy is ours. Of his Empress, Eugénie, Worth said in interview: "Not that she is indifferent in the matter of dress. Quite the contrary…The point is that she trusts our judgment rather than her own." If even the Empress relinquished her judgment, about what she would wear and how she would wear it, what hope for the rest of us? With Worth, taste in dress began to be given up as a life skill and to be placed in the hands of professionals, of the craftsmen-soon-to-be artists in whose judgment we trusted but who, by virtue of their increasing identification with art, began to despise the everyday purposes and petty economies of our lives and to produce clothes not meant for us to wear. And so, dress came gradually away from all mooring, as those assigned to create clothes no longer cared about wearing them, and those who had to wear clothes no longer knew about judging them. And in-between: a massive industry, making the profits to be had from cheap incorporations of the inventiveness of the creators and from the lack of judgment of the wearers; and a forgotten capacity, for *know-how* in the making and wearing of clothes. The value of disinterest, now definitive of art, is a double edged sword, it would seem: taking from creativity the craft that would make it wearable, that would make it useful; and exposing those who wear, who use, who go about the business of living, to all of the obsolescences and renewals unleashed by the wane of judgment, of taste. Disinterest, then, pursues both permanence (it has no investment in time and place) and an almost total evanescence (it

has no connection with time and place); it is, in this sense, the enemy of human existence twice over, first because the human changes and then because the human does not change quickly or continuously enough.

Beuys's dream of every living person becoming an artist has, then, something of the nightmare about it. His hope was for the realization of democracy in its truest sense, but the truth is that the simultaneous disinterest of artists and disengagement of "the people," which is the effect of the contemporary constitution of art, serves only that mode of democracy that we call "liberal" and that purchases its freedoms at the expense of its skills and its tastes, at the expense of its judgment and its criticism. Gilles Lipovetsky makes this point in *The Empire of Fashion*, when he argues for the "rationalizing" effect of the frivolity incubated by contemporary dress. Gone, Lipovetsky says, are those Platonic days when the passing nature of worldly appearances was regarded as an *obstacle* to reason and to truth; now, he says, our constant exposure to change for change's sake, our total immersion in the ever-shifting styles that are as superficially adopted as they are carelessly relinquished, results in a general lassitude of thought, in what Lipovetsky calls a "spirit of tolerance," that has not had to be hard won through reason but has been softly sold to us through our unending exposure to ephemera, which, ironically, need now be less and less fleeting and contrasting as we grow more and more modest, more and more inert, in our expectations of a human existence. Lipovetsky describes this as the "frivolous wisdom" of the modern age, and as a humanization of the unwarranted and alienating grandeur of the past. And he is not alone. Danto, too, welcomes the kind of wisdom that arises from what he calls the "end of art" in the 1960s, after which any kind of object or event, any style and any commitment, may be art. The survival of art, the fact that we continue to produce it and to visit it and to think of it after this point, is a great sign, for Danto, that tolerance of differences, that

the coexistence of incompatibles, is possible and productive. "How wonderful it would be," he writes, "to believe that the pluralistic art world of the historical present is a harbinger of political things to come!"

But at what cost have such wonderful "freedom" and "tolerance" been achieved? And how do they really function? Yes, we citizens of liberal democracy are more or less "free" to live as we choose, to be as creative as we wish, but a creativity that is this "free" is a creativity for which art is both emblematic and incubatory: a creativity that is by definition removed from life, by definition to no purpose, by definition with no interest or stake, by definition of no use or application. And, yes, we citizens of liberal democracy are wonderfully "tolerant" of differences, content to coexist with others of almost any kind, but it is a tolerance that considers all differences to be trivial ones and all aspects of human life to be superficial, and that comprises nothing much more than the inertia that arises from this consideration; what need for reform, what reason for revolution, when nothing is really different from anything else, when differences are nothing more than cheaply made overcoats that one can take on and off pretty much at will? The fact that capitalism thrives on the freedom and tolerance of liberal democracies is certainly one reason for being suspicious: the separation of creativity from craft plays right into the hands of an economic system that demands constant regeneration at the lowest cost; and the separation of living from judging results in a population of "consumers" for which there is no reason not to buy whatever product is put before it. But the forces of capital are not the end of this story. For, the fact that *commitment* is more or less removed as a possibility in liberal democracies is even more climactic than the fact that capital is more or less at large: the erosion of craft and of taste has made a very docile population, obediently lined up along a spectrum that ranges from creativity without purpose to conservatism without purpose, from artists in their back-street

studios to shoppers in their high-street stores.

This story of fashion become art, and therefore acquiescence, is neatly summarized by the most famous living British designer, Vivienne Westwood, who began her career as a dressmaker who wanted to sell clothes to undermine the perceived conservatism of 1970s England and is ending it as a fashion designer, elements of whose collections are regularly purchased for display by the Victoria and Albert museum in London. In a 1981 interview with Jon Savage, Westwood declared that her sole interest in fashion was in its potential for confronting the Establishment and finding out "where freedom lies and what you can do." "The only reason I'm in fashion is to destroy the word 'conformity,'" she said. "Nothing's interesting to me unless it's got that element." Five years later, her hunger for that fight appears to have waned; "I got tired," she confessed to *I-D* magazine, "of looking at clothes from this point of view of rebellion—I found it exhausting and after a while I wasn't sure if I was right. I'm sure that if there is such a thing as the 'Anti-Establishment'—it feeds the Establishment." A more concise summary of the kettling effect of liberal democratic "freedom" and "tolerance," artistically conceived, could hardly be composed, as the most infamously irreverent contributor to twentieth-century British fashion finally realizes the effective impossibly of irreverence. But Westwood's capitulation was always her fate, from her early support of the anyone-can-do-it aesthetic that was Punk—which mistook the abandonment of craft, skill, talent and application as a triumph of creativity-for-the-people—to her later entry to the world of *haute couture*, in which world she is perhaps best known for her eclectic reanimations of the fabrics and cuts of historical styles of dress, plucked, as they were by Worth, from their time and place and sent down the runway in not very discriminating, and rather badly made, juxtaposition.

But it has been a long time since Worth; and the highly developed skills that he brought to the endless round of

innovation that became *couture*, and which took a long time to wane even though the defining aspect of *couture* was always its "creativity" rather than its craft, have, with Westwood, at last fulfilled their modern fate and gone by the wayside. In 1983, Valerie Mendes acquired the V&A's first Westwood piece: a Pirate outfit, then on sale in World's End, the shop at 430 King's Road in London, where Westwood was selling her products. It was a very daring move, Mendes recalls, "because it was a break away from *haute couture*." In effect, then, Westwood was there at the final separation of fashion-as-art from the craft of dress-making that *couture* had still to completely relinquish from its devotion to "creativity" as constant renewal; her designs often foreground the lack of finish, the lack of craft, that *couture* had set in place as the fate of dress. On being asked in interview about thinking of herself as a designer, Westwood answered: "I realized that I didn't have to qualify my ideas. I could do anything I liked...I could go on forever." And doing anything she liked now extended, not only to the content of her work but, at last, completely to its craft. Her ideas need now be qualified neither by rhyme and reason nor by realization. And so, there was no stopping her. She could go on forever.

But this "freedom" to go on forever is one of the most effective elements of the art kettle, and one of the stakes in our account of Manet in the last chapter. *Manet*: "he remains"! How inappropriate!: Manet painted in order to put aside this remaining, this going on forever, as the inhuman aspiration of an inhuman art. And he did this also by painting *dress*.

It is a tangled web we wove during the latter half of the nineteenth century, which has left us not knowing how to dress ourselves. A central thread of this web was certainly the recurring identification of the falling folds of fabric associated with ancient Classical times as a foil for the merely superficial shifts of fashion. Another was the gradual emphasis on the superficial shifts of fashion as *pretext*s for a non-superficial Truth

that modern times have been too modern to attach to any particular colour or cut but too Classical still to accept as outside of human possibility. In fashion, then, we have another instance of the move from the traditional pursuit of something more than human through application to Classical styles as "true," to the modern pursuit of something more than human by a constant display of contempt for every style on the grounds that every style is merely human. And Manet saw it all.

Le Déjeuner sur L'Herbe, which made Manet one of a company with Whistler in ejection from the *Salon* of 1863, presents us with a Classical nude, incongruously at a picnic with two very modern men. Here, we have said, is juxtaposed Ruskin's reliance on the effect of truth in Classical form with Whistler's concern with the artistic effect of carelessly rendered details of modern life. But then our eye falls on the spotted muslin dress that lies crumpled by our goddess's side. There is no incongruity after all, only indecency: our Classical nude is a modern woman who has taken her clothes off! But now the incongruity works another way. For, by her side are men whose attire, though contemporary, is not merely fashionable. They are wearing bows, and soft hats, and loosely cut clothes. They are *dandies*, very familiar figures at that time and described by Baudelaire, in his "The Painter of Modern Life," as those committed to fashioning themselves as works of art; the dandy has "no profession other than elegance," he wrote, and must live and sleep before a mirror. There is, then, in *Déjeuner*, the story of art told through dress. The nude-become-naked is, of course, a good device to undermine the alleged commitment to the abandonment of the Classical by "modern painters": the nude is also naked; the goddess is also human; the modern is also Classical. But there is more than this. Though initially startlingly Classical, the female figure in the foreground is subsequently seen as quintessentially modern, by virtue of a very significant sartorial version of modern art's employment of the arts of a merely human existence as *pretexts* for something

more-than-human: X-rays of the painting show that Manet added the muslin dress only once the painting was otherwise finished; it was, in effect, put on and pulled off in the same movement, painted in in a manner to show up that such details are, by modern artists, painted in and painted over in the same moment, painted in merely as pretexts for "painting itself." In many ways, then, our supposedly modern men are the more Classical, attempting to fashion themselves in a manner to raise them above the vagaries of life and its mere human purposes, in order to achieve the status of a work of art; if they had been living in England, they would have been members of the Aesthetic Dress Movement. In Manet's *Déjeuner*, in short, we have a depiction, by the painting of dress, of the stakes in Whistler's trial at the Old Bailey: there is our female figure, who looks to achieve a more-than-human truth by a display of naked contempt for the details of merely human existence that lie crumpled by her side; and there are our men, our quasi-"togo'd buffoons" (as Mayor Johnson used the occasion of the mounting of Gormley's *One and Other* to describe the more traditional artworks on display in Trafalgar Square) who would more directly attempt a *fully clothed* contempt for mere human triviality, by adopting a mode of attire (very like that of Worth-as-Rembrandt, and with the loose and flowing lines that the Aesthetic Dress Movement understood as a revival of the Classical) that was true.

On the lintel of Vivienne Westwood's King's Road shop, when it was called "Sex," there was spray painted the aphorism, "Craft must have clothes, but Truth loves to go naked." But there are more ways than one to go naked: dressing in clothes whose falling folds are understood to have all the truth of Classical folds of flesh is one; dressing in defiance of dress itself is another. Meanwhile, the craft of making and wearing clothes is crumpled up in contempt, shrunk to the insignificance in which Bataille rejoices when he looks so askew at Manet's work.

But what of the men in black frock coats and top hats, so prevalent in others of Manet's paintings as to cloak half of the canvas in their almost unbroken black? They are marked by their absence from *Déjeuner*, which is a painting that uses dress to tell the story of art; black frock coats and top hats have no place in this story, for they are the clothes of the men on the streets of the time, and not the clothes of naked truth. But these black frock coats and top hats are themselves a less than straightforward choice of dress. Take their dominance over the canvas of Manet's *Masked Ball at the Opera*, which is more than half-covered in black suits. How unusual an effect this produces, making it impossible to ignore the contrast between the men in black and those others, mostly women, attired in brightly coloured, and rather scanty, costumes. But the contrast is an important one. Previous to these later decades of the nineteenth century, men's dress had been much more elaborate, as elaborate, or almost, as that of women. The emergence of their black suit and hat only began with the emergence of women's fashion as the changeful and arbitrary round of substitutions that was incubated by *couture* and that extended the defining characteristics of dress for fancy dress parties — wilful juxtaposition of historical styles and lack of connection with everyday living — to dress for the business of life. In an important sense, then, the black suit and top hat was as deliberate a stand against the degrading effects of fashion-as-art, as Manet's paintings were a deliberate stand against the degrading effects of painting-as-art. And there he is, Manet, there among the men thronging into the ball at the opera: there, in black frock coat and top hat, with blond hair and beard, staring straight out from the right hand side of the canvas, his dance card — empty except for his signature — fallen to the floor. There was nobody, after all, to dance with Manet, for which the proximity of Regent Street to Trafalgar Square that allowed Worth such easy lunchtime access to London's National Gallery of Art is in part responsible.

That Trafalgar Square, which lies within the northern parameter of the Parliament Square exclusion zone designated by the Serious Organized Crime and Police Act of 2005, is actually excluded from the terms of the Act, in honour of its historical associations with political resistance, is something of an irony, and, we might think, at least one piece of unnecessary legislation in the Whitehall filing cabinets; with the National Gallery along one of its sides, the *museum contagion* that makes art out of protest, rhetoric out of resistance, and democracy into display, must be particularly potent there.

8

Put the Kettle On, and We'll Make a Cup of Tea

The penultimate chapter of Michel Foucault's *Madness and Civilization* refers us to an asylum for the insane, established in 1796 just outside the city of York and the brainchild of William Tuke, a member of the Society of Friends and a man bent on social reform. The York Retreat, as it was called, was one of the first of its kind, and marks, as Foucault tells it, a transformation, from the constitution of madness as a form of animality that is most appropriately shut away behind bars and in chains, to the constitution of madness as a disease, for which the patient is to be treated and of which he or she just might be cured. In the York Retreat, physical constraint was largely dispensed with, as inhumane and ineffective; instead, patients were generally free to move about and enter into practice for normal life in a manner directed by their own evaluation and control of their own thoughts and actions. In modern parlance, they learned to *own* their condition and thereby to master it. There were even tea parties, run along formal English lines, at which patients mingled with staff and other patients and were treated with all of the formality and attentiveness of the hospitality shown to respected strangers. In short, Tuke's asylum has gone down in history as marking a great liberation of the insane, which contemporary attitudes to, and treatment of, mental disability continue to bring to fruition.

And yet, Foucault encourages us to question the terms of this great liberation, to bracket for a moment the almost instinctive supposition that it *must* have been a better way, a more humane way, a more progressive way, a more enlightened way, in order to

consider the possibility that even great liberations may also imprison, and even enlightenment also enchain. Those English tea parties, set with delicate china and tiny morsels, full of formalities with little purpose other than to see and be seen, were after all a very good device for replacing the bars and chains of old with the *self-restraint* produced apparently so amicably, so innocently, and so invitingly, by an occasion on which possibilities for tiny infractions of social norms were as plentiful as the opportunities for others to observe and to judge them. For the constitution of madness as an illness brought with it two effects, the tension between which functioned, and continues to function, as a form of constraint at least as difficult to breach as an iron cage. First, is the effect of *lack of control*; the patient is suffering from a disease and is therefore as relieved of the determination of its presence and progress as one suffering from, say, a form of cancer. Second, is the effect of *guilt*; the liberation of the insane into life as a round of tea parties functioned to expose them to the constant and minute monitoring, which such occasions—even in the outside world—incubate so well, and which instils a proportionate impulse to *self*-monitoring and fashions a patient who feels guilty at her smallest transgression of the bounds of the normal. Tuke's great liberation of the insane, Foucault would convince us, was a move from the explicit constraints of the dungeon to the implicit constraint of the constitution of madness as that over which the patient has no control but for which the patient is yet endlessly guilty. The madman was no longer animal; he was now, and has been ever since, the *stranger* whose strangeness must never show itself, in even the most trivial of ways.

In short, Foucault would have us accept that in the modern age it is impossible to be irrational, insofar as both rationality and irrationality are constituted in entirely reasonable terms. One may run mad, of course, but that "madness" will be so carefully categorized and monitored, so documented and

analysed, so systematically revealed and guiltily concealed, that it will be reasonable even in its unreasonableness. One may run mad, but one will not run free. Not, that is, unless one runs with *art*; so says Foucault, at the close of *Madness and Civilization*, when he names the "lightning-flash" of works of art such as those of Hölderlin and Artaud as "forever irreducible to those alienations that can be cured, resisting by their own strength that gigantic moral imprisonment which we are in the habit of calling the liberation of the insane." This is not simply because a startling amount of modern art has been produced by individuals who were mad—as if madness burst forth from them as an expression outside of the reasonable round of rationality and irrationality that makes the modern mad so sane; this fact is, for Foucault, but a signpost to the unreason of art, which has, in fact, no relation to madness that would bring it into the fold of reason once more. The work of art, as Foucault describes it, "endlessly drives madness to its limits; *where there is a work of art, there is no madness.*" And there is more even than this: for Foucault, art is contemporaneous with madness in its modern form, the overspill of a drive for enlightenment that would recognize only the irrationality that can be reasonable. It is thus that the work of art, for Foucault, functions to reprimand the modern world, to bring it up short, to call it to account, to give it a sense of its limits, to model its resistance: "The moment when, together, the work of art and madness are born and fulfilled is the beginning of the time when the world finds itself arraigned by that work of art and responsible for what it is." Our world must justify itself before the unreasonable madness of art.

The purpose of this book has been to question the alleged "unreasonableness" of art, to caution against the identification of creativity-as-art as holding out the possibility for social and political critique and resistance; more than this, the aim has been to demonstrate that contemporary art—and the capacity for creative thought and action that it regulates by nourishing—is

what Foucault would call a *discipline*, that is, one of the ways in which citizens are kept in good order, by a political system in which old styles of prohibitive, top-down, spectacular power have waned in favour of the now much more efficient regulation brought about by operations that are perceived to be liberating. What need now of bars and chains when the very sense of release from such "barbarous" restraints has had the effect of driving whole swathes of the populace into that round of ceding control and feeling guilt that constitutes our more "enlightened" knowledge of mental illness? And what need now of limiting exposure to ideas, and of denying freedom to give creative expression to them, when the very terms of creativity make creativity useless, that is, without interest or purpose, so caught up in the nature of itself that it has lost sight of the nature of anything else?

But there is more. Thatcher's "Care in the Community" programme of the 1980s, in completing the "liberation" of the insane begun by Tuke and on the terms set down by Tuke as well, effectively gave rise to an *asylum without walls*, so that those suffering under psychological conditions experienced as abnormal had now to cope with the almost endless opportunities for guilty self-regulation that arise once the whole world is effectively laid out for tea, and the rest of us non-sufferers were drawn into the fold by a constant watchfulness, of those whose behaviour is "abnormal" and "out of control," and of ourselves who feel drawn towards the liberation of diagnostic and therapeutic practices. And, analogously, the anything-anywhere-anyone-anyhow matrix of contemporary art operates effectively as a programme for "Creativity in the Community" and produces a *museum without walls* that has realized the insights of Malraux much more fully than he predicted, as the gradual relinquishment by modern art of attachment to any particular style, technique or subject matter has had the effect of opening up infinite "possibilities" for art and thereby of extending the range

of "disinterestedness" out beyond the museum and into not only our holidays and our hobbies, but also our homes and our relationships, and also our protests and our resistances. There is, we might say, now *a museum continuum*, whereby anything explicitly creative is subject to all of the conditions—of clinical purposelessness and elevated remove—incubated, both architecturally and institutionally, by the like of Tate Britain, and anything regular, purposeful, useful, engaged and interested is consigned to the merely instrumentalist other side of the creativity coin. Thus, Wallinger's *State Britain*, in being art and therefore purposeless, is exempt from the Serious Organized Crime and Police Act that would otherwise have made it illegal; and Brian Haw's protest against the invasion of Iraq is, while it lasted, welcomed with open arms by the polity it would criticize, because anything so anathema to the means and ends of day-to-day life is valued precisely for that: for stepping outside of day-to-day life, for being creative, for being resistant, for being protesting, which is welcomed as a good in itself, irrespective of the content to which it merely happens to be attached. The Serious Organized Crime and Police Act, which became law in 2005 and ruled out unauthorized protests within one kilometre of Parliament Square, can, in this context, be regarded as something of an anachronism, operating in top-down traditional manner, both to prohibit protests that would, almost of necessity, be doing no harm, and to hinder (or maybe just to hide) the very regulative effect produced by an implicit display of political tolerance that will always trump the explicit display of political resistance.

And "Creativity in the Community" is now officially recognized, as an aesthetic commitment in its own right and actually definitive of contemporary art; Nicolas Bourriaud, recently curator at Tate Britain, is author of an account of art that has had a huge influence on the artworld in Britain during the last decade or so and that describes art as operating, now, *relationally*. Art, according to Bourriaud, has moved on from its twentieth-century

concern with its internal conditions (from what we have called here, the "It's not art"/"It *is* art" loop) to a twenty-first century emphasis on its external conditions, that is, on the manner in which human relations in social and political context operate creatively. This, according to Bourriaud, has had the effect of neutralizing the autonomous and exclusive mode of existence characteristic of art, like Whistler's, with "artistic interests" only, and of moving art out into the community, as a truly democratic possibility, not seeking "to transcend our day to day preoccupations," but bringing us "face to face with reality" and incubating "a vision that is quite simply *human*."

One of the artworks that Bourriaud uses as exemplary is by an artist called Gonzalez-Torres, who produced a work in which handfuls of sweets were exhibited in such a way as to be easily accessible to the public. What followed was a range of behaviour, some grabbing sweets to cram into their pockets, others hesitating and taking a few, others again passing on without taking any. According to Bourriaud, the "visitors were being confronted with their own social behaviour, fetishism and acquisitive worldview." But all of this seems rather sinisterly reminiscent of William Tuke's terrible tea party, does it not, except that the fare is rather less nourishing and the table rather more poorly laid out? For, just as tea-for-the-mad constituted the mad person as the stranger whose strangeness must never be seen, so sweets-for-the-public constitutes the public as *the visitor who is never at home*, who is never really involved, who is never really addressed, who never really takes part, and whose behaviour around Gonzales-Torres's offerings reveals nothing more than the "visitor"'s relation to art. The encounter with the sweets must, according to Bourriaud, "be subject to criteria analogous with those on which we base our evaluation of any constructed social reality." I think not; for no other constructed social reality has about it the unreality of art. (At least, I *hope* not: the museum continuum may yet prove Bourriaud horribly right.)

The "space" of the artworks that Bourriaud admires is, as he describes it, "devoted entirely to interaction." "It is a space for openness," he says, "that inaugurates all dialogue." Elsewhere in the same text, he describes contemporary art as "the opening of a dialogue that never ends." But herein lies the rub: *human* interaction is never inaugurated in a space straightforwardly "open," and *human* interaction is never endless. Why? Because human existence is finite and historical, which has the effect of channelling it in all kinds of ways that map out, square off, and rearrange the "open space" that for Bourriaud is so significant, and which gives rise to those inevitable trajectories, those particular purposes, those given projects, that always bring to some ends those interactions that Bourriaud fashions as endless. And it is precisely these human channellings and trajectories, these human means and ends, that Bourriaud's artworks, as inheritors of a hankering after divinity, just cannot confront. He describes another artwork, this time by an Angus Fairhurst, in which a phone link was established between two art galleries, representatives of which, when their phones rang, answered on the assumption that the other had made the call. Is this one of those human interactions of which Bourriaud speaks, which begins nowhere (nobody "made" the call) and has no end in sight (apart from the realization of an artwork, there was no purpose to the call, neither caller having had anything to say)? If so, we may observe that it is remarkable for being like, not all dialogue as Bourriaud hopes, but almost no dialogue on earth! It is very like all modern art, however, in its continuing display of contempt for the merely human beginnings and endings, the importance of which the "open spaces" of the art museum would diminish, and the judgment necessary to negotiating which is certainly not enhanced by looking at art. "Contemporary art is really pursuing a political project when it attempts to move into the relational sphere," says Bourriaud. He is right of course, but not as he knows it.

Bourriaud wrote the introduction to the English translation of a book comprised of a lecture that Foucault gave on Manet, in which introduction Bourriaud summarizes Foucault's interpretation of Manet's work as "painting that refers to painting." And it is true, Foucault does propose a reading of Manet very much along the lines of Bataille, who rejoices, as we recall, in the alleged indifference of Manet to the details of a merely human existence and in Manet's allegedly employing his subject matter in a manner to make it shrink to insignificance beside his "artistic interest" in the conditions of possibility of art. We have challenged this reading of Manet here, but is it not strange that Foucault too develops an account of modern art premised upon the conviction that the merely finite does not represent the limits of human possibility? Is it not strange that Foucault too holds out for humanity the more-than-human freedom allegedly available through art, he, who was so attuned to the disciplinary effects of the "freedoms" that mount up everywhere else? Strange, but true; and one effect of that very persistent notion that only an *inhuman* truth can save humanity. It is no coincidence that one of Foucault's favourites, the Romantic Hölderlin, wrote hermetic poems as an outlet for his very Platonic understanding of the relation between poetry and divinity, and that another of Foucault's favourites, the Surrealist Artaud, recommended, among other things, the practice of automatic writing as a means, effectively, of taking mere human rationality out of the creative process: the pursuit of divinity, or, at least, the contempt for humanity; this is the "freedom" that constitutes art in our time, the "freedom" that even Foucault identifies as the only way left to us to call this world of ours to some account. The object of this book, however, has been to show that one can run mad *and* run free, but still not run *free*.

Nor walk free either. Artaud's Surrealists recommended as a form of truly unreasonable art, the wandering around the city, without aim or agenda, that they called a *dérive*; this wandering,

they held up as a challenge to the merely rational order with which we usually negotiate the city's streets and a consequent tapping into that which lies outside of the too ends-oriented activities of our so *human* lives. Here again, we have the application to a purposefully non-purposeful activity as the truest mode of critique, a setting at nought of all those interests and engagements that regulate the directions of our lives in favour of a disinterest and disengagement that juxtapose themselves with interests and engagements in order to use them as pretexts, as what Bataille would call "byways to profundity": when even Hölderlin's faith in divinity is no longer possible, one wanders with Artaud around the museum without walls, with nothing to aim for but a profundity purchased with a hearty contempt for the byways of humanity. Of course, the Surrealists would not recognize themselves in this description. They would claim that they sought only to release a truly human potential from beneath the yoke of ends-oriented forms of rationality that have been so successfully co-opted by capital; it is only human reason they sought to undermine, they would say, and not the human itself. Further, they would regard the identification of the human entirely with reason as alienating of humanity from its liberation by an unreasonable creativity. But then we would reply that the truly human potential they champion is the modern, secular equivalent of a divinity purchased at the expense of humanity, and that the identification of purposeful activity as entirely, and merely, ends-oriented, and the plaything of capital, amounts to another alienation: of the purposes of the craftsman, for instance, who takes a pleasure in his work that is not entirely commensurate with profit; of the interests of the painter, for instance, who seeks to address an audience with an end in view that is also open and negotiable; and of the judgments of the dressmaker, for instance, whose alterations function to domesticate the achievement of taste and to put a stay upon the combination of *couture* and consumption that has so devastated that

achievement.

In the late eighteenth century, Kant tried to give an answer to two, related, questions: one was, whether or not the human race was improving; the other was, how to define the nature of enlightenment. In his responses, Kant implies that the gradual enlightenment of humanity relies upon a human capacity for disinterest that is fleshed out by the contrast it makes with the *merely* human capacity for resistance. In his consideration of the question about enlightenment, Kant identifies as the mark of an enlightened polity a distinction between public and private that ensures that, however thoughtful and committed citizens are in their criticisms of prevailing social and political conditions, they continue to perform their public duties as required and in good order. "Argue as much as you like, but obey"!: this is Kant's advice to a would-be enlightened public. In his response to the matter of improvement, Kant identifies as the sign of progress the enthusiasm that he claims recently to have been struck by, as exhibited by those who *looked on* at the revolution in France, those Kant describes as sufficiently removed, both from the events themselves and from a sense of their personal stake in those events, that they were capable of experiencing pleasure at the revolution as one of those forward movements that signify the possibility of human progress. As things of their time, there may be something to Kant's distinctions, between public and private commitment, and between revolutionary and onlooker to the revolution: they were times of social and economic upheaval, in which the recommendation that resistance be conducted in such a manner as to facilitate the continued functioning of the state may have been a piece of very good advice; and they were times of political turmoil, in which the alacrity with which people appeared ready to sign up to a programme for revolution may indeed have had its appropriate regulation in those whose enthusiasm for progress was of the more abstract kind that could, perhaps, furnish the ideals for which revolution ought to

strive. At any rate, emergent from Kant's answers to these big questions was *the reasonable man*, the one who knew to restrict his resistances to private life and who was elevated by a sense of human progress in proportion to the extent of his remove from the inevitably imperfect manner in which it would, by mere humans, be brought about.

And look, now, what has become of this reasonable man. He is *confined*, in a liberal democratic polity that has, by this time, banished everything to the private sphere that is not entirely "liberal," not entirely "neutral" and "transparent," which has had the effect of filling up the private sphere to such a degree that an almost total apathy, the private counterpart to public "tolerance," prevails there. And he is *released*, by that liberal democracy into all of the "unreasonable," "crazy," "creative," anything-goes experiences that are to be had from relinquishing purpose altogether and just "letting it all hang out." In effect, the modern legacy of Kant's reasonable man is our *private onlooker*, the one who goes with the flow of public life because of its constant juxtaposition with time off, with holidays, hobbies, lunchtimes and weekends, and the one who spends his time off in pursuit of a pleasure whose central ingredient is, at the very most, disinterest, but, increasingly, a simple *looking on*. One of our favourite national pastimes now is to watch TV programmes about cooking, and home improvement, and craft. But fewer of us than ever are baking bread or painting windows or sewing quilts. (That another of our favourite national pastimes now is to watch TV programmes about "real life" speaks, perhaps, for itself.) We have, in short, utterly conceded human reason to the workings of capital, as that merely instrumentalist subsumption of means to given ends that is so malleable in the hands of profit, tempted by the abandonment promised elsewhere by the avail-ability of an "unreason" that has constituted, and been incubated by, the modern history of art, and that operates very well to console and to control a population whose capacities have been

divided up, into the obedient pursuit of given ends that makes the population so efficient and the enthusiastic pursuit of given pleasures that is now gradually and seamlessly transforming into a kind of anaesthetized spectatorship.

It was, then, only in the course of things that art too, that area of activity that has fostered our population of private onlookers, should be consumed by its own logic: in 1964, according to Danto, art came to an end and entered an age—an age without end—when art can be anything at all and only those who look on at art are of significance. He would not for the world have been an artist in this age, Danto confesses, but it is great sport to be a thoughtful onlooker. But the time came for thought, too, to be brought into the fold. Nicolas Bourriaud was co-director of *Palais de Tokyo* when, in 2004, it held an exhibition in which was "mounted" a work entitled *24h Foucault*, which described itself as a sort of summary of a much more extensive work, *The Foucault Art Project*, and which was apparently comprised of the ingredients of a standard academic conference on the work of Foucault apart from the small difference that the souvenirs in the conference shop were not to be sold and the works of Foucault were not to be understood. "I don't know Foucault's philosophy," the artist mostly responsible for the artwork wrote in its advertisement, "but I see his work of art." Poor Foucault. Become art, one can look but definitely not touch. The "visitor" as *onlooker*: the museum, now at last without walls.

Is there another option remaining, than these options delivered to us by the division of means from ends, of beauty from use, that is almost definitive of modern life? Can we be other than obediently reasonable and obediently unreasonable? I think, yes. Bourriaud establishes his account of relational art against those he describes as "fundamentalist believers in yesterday's *good taste*." Fundamentalism is a much tainted word in the West at present, and difficult to pick up and brush off. But it is a kind of fundamentalism that is required to loosen the hold

of this awful reasonableness that makes us dull even when we are being creative, and obedient even when we are being resistant; a kind of fundamentalism that identifies ends that are worth pursuing and commits itself to their realization, and that practices means that are both purposeful and pleasurable, both useful and enriching; a kind of fundamentalism that, as Bourriaud describes it, is very like that outdated thing we call *good taste*. And, if this sounds naive, anachronistic, and exclusive, then so it should sound *naive* to a world now so sophisticated that nothing arouses its interest, and *anachronistic* to a world now gone over a century from a time when the judgment of taste might have won the day, and *exclusive* to a world bent on being so inclusive that nothing is allowed to be worth anything but what somebody else will pay for it. "A fundamentalist believer in yesterday's *good taste*": guilty as charged, your honour.

Acknowledgments

Thank you to my husband, Lars, who told me about Zero and encouraged me to write for them, and whose conversation makes me think more interestingly and write more committedly. Thank you, too, to my friend, Tony, who read through, and made comments on, this book as it was in progress, without which help many more things would be wrong with it than are wrong with it now. And thank you, finally, to my small boy, who was very good while I wrote this.

Contemporary culture has eliminated both the concept of the public and the figure of the intellectual. Former public spaces – both physical and cultural – are now either derelict or colonized by advertising. A cretinous anti-intellectualism presides, cheerled by expensively educated hacks in the pay of multinational corporations who reassure their bored readers that there is no need to rouse themselves from their interpassive stupor. The informal censorship internalized and propagated by the cultural workers of late capitalism generates a banal conformity that the propaganda chiefs of Stalinism could only ever have dreamt of imposing. Zer0 Books knows that another kind of discourse – intellectual without being academic, popular without being populist – is not only possible: it is already flourishing, in the regions beyond the striplit malls of so-called mass media and the neurotically bureaucratic halls of the academy. Zer0 is committed to the idea of publishing as a making public of the intellectual. It is convinced that in the unthinking, blandly consensual culture in which we live, critical and engaged theoretical reflection is more important than ever before.